MARIA

MARIA

POPE BENEDICT XVI
ON THE MOTHER OF GOD

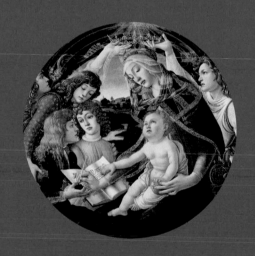

IGNATIUS PRESS SAN FRANCISCO

Original German edition:
Maria: Papst Benedikt XVI. Über die Gottesmutter
© 2008 by Libreria Editrice Vaticana, Vatican City
© 2008 by Sankt Ulrich Verlag, GmbH, Augsburg, Germany

Cover photograph by Stefano Spaziani

© 2009 by Libreria Editrice Vaticana, Vatican City
© 2009 by Ignatius Press, San Francisco
ISBN 978-1-58617-307-4
Library of Congress Control Number 2009923632
Printed in Canada ∞

CONTENTS

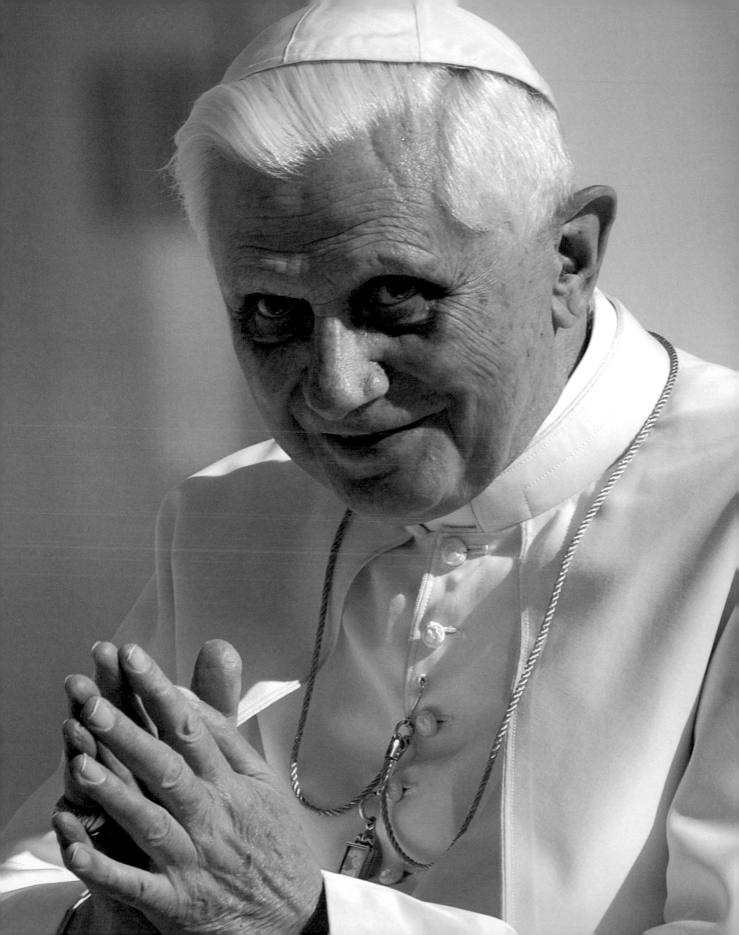

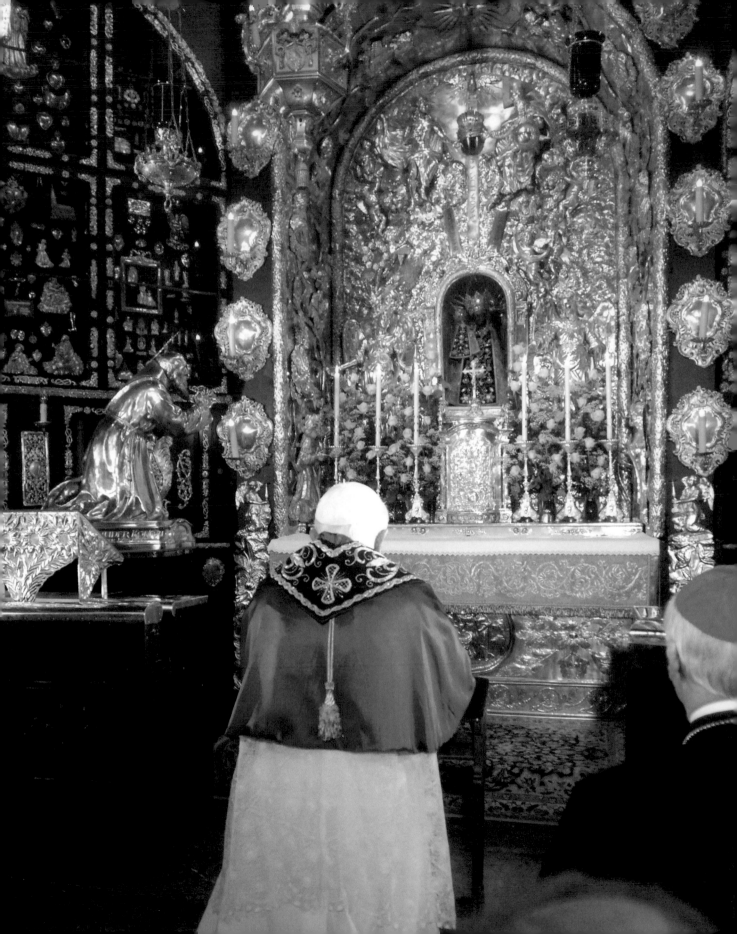

LEAD US TO JESUS

In the Gospel passage [recounting the wedding at Cana], Mary makes a request of her Son on behalf of some friends in need. At first sight, this could appear to be an entirely human conversation between a Mother and her Son, and it is indeed a dialogue rich in humanity. Yet Mary does not speak to Jesus as if he were a mere man on whose ability and helpfulness she can count. She entrusts a human need to his power—to a power which is more than skill and human ability. In this dialogue with Jesus, we actually see her as a Mother who asks, one who intercedes. As we listen to this Gospel passage, it is worth going a little deeper, not only to understand Jesus and Mary better, but also to learn from Mary the right way to pray. Mary does not really ask something of Jesus: she simply says to him: "They have no wine" (Jn 2:3). Weddings in the Holy Land were celebrated for a whole week; the entire town took part, and consequently much wine was consumed. Now the bride and groom find themselves in trouble, and Mary simply says this to Jesus. She does not ask for anything specific, much less that Jesus exercise his power, perform a miracle, produce wine. She simply hands the matter over to Jesus and leaves it to him to decide about what to do. In the simple words of the Mother of Jesus, then, we can see two things: on the one hand, her affectionate concern for people, that maternal affection which makes her aware of the problems of others. We see her heartfelt goodness and her willingness to help. This is the Mother that generations of people have come here to Altötting to visit. To her we entrust our cares, our needs and our troubles. Her maternal readiness to help, in which we trust, appears here for the first time in the Holy Scriptures. But in addition to this first aspect, with which we are all familiar, there is another, which we could easily overlook: Mary leaves everything to the Lord's judgment. At Nazareth she gave over her will, immersing it in the will of God: "Here am I, the servant of the Lord; let it be with me according to your word" (Lk 1:38). And this continues to be her fundamental attitude. This is how she teaches us to pray:

Pope Benedict XVI in the Chapel of Grace in Altötting, September 11, 2006

not by seeking to assert before God our own will and our own desires, however important they may be—however reasonable they might appear to us—but rather to bring them before him and to let him decide what he intends to do. From Mary we learn graciousness and readiness to help, but we also learn humility and generosity in accepting God's will, in the confident conviction that, whatever it may be, it will be our, and my own, true good.

We can understand, I think, very well the attitude and words of Mary, yet we still find it very hard to understand Jesus' answer. In the first place, we do not like the way he addresses her: "Woman". Why does he not say: "Mother"? But this title really expresses Mary's place in salvation history. It points to the future, to the hour of the crucifixion, when Jesus will say to her: "Woman, behold your son—Son, behold your mother" (cf. Jn 19:26–27). It anticipates the hour when he will make the woman, his Mother, the Mother of all his disciples. On the other hand, the title "Woman" recalls the account of the creation of Eve: Adam, surrounded by creation in all its

magnificence, experiences loneliness as a human being. Then Eve is created, and in her Adam finds the companion for whom he longed; and he gives her the name "Woman". In the Gospel of John, then, Mary represents the new, the definitive woman, the companion of the Redeemer, our Mother: the name, which seemed so lacking in affection, actually expresses the grandeur of Mary's enduring mission.

Yet we like even less what Jesus at Cana then says to Mary: "Woman, what have I to do with you? My hour has not yet come" (Jn 2:4). We want to object: you have a lot to do with her! It was Mary who gave you flesh and blood, who gave you your body, and not only your body: with the "yes" which rose from the depths of her heart she bore you in her womb and with a Mother's love she gave you life and introduced you to the community of the people of Israel. But if this is how we speak to Jesus, then we are already well along the way towards understanding his answer. Because all this should remind us that at the Incarnation of Jesus two dialogues took place; the two go together and blend into one. First, there is Mary's dialogue with the Archangel

Mother of Grace statue, Altötting

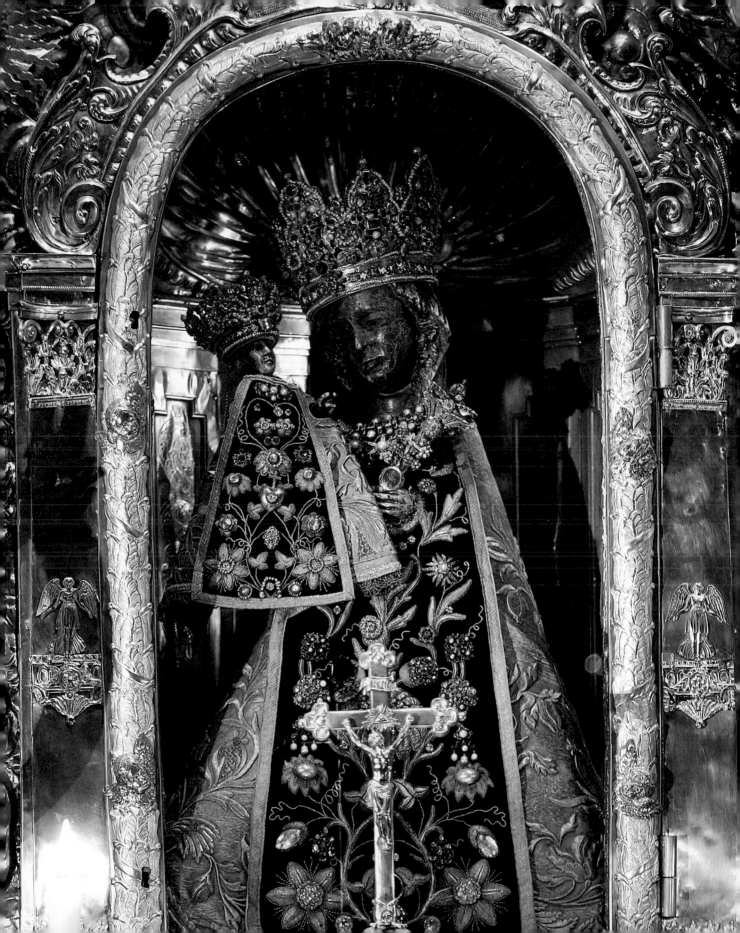

Gabriel, where she says: "Let it be with me according to your word" (Lk 1:38). But there is a text parallel to this, so to speak, within God himself, which we read about in the Letter to the Hebrews, when it says that the words of Psalm 40 became a kind of dialogue between the Father and the Son—a dialogue which set in motion the Incarnation. The Eternal Son says to the Father: "Sacrifices and offerings you have not desired, but a body you have prepared for me. . . . See, I have come to do your will" (Heb 10:5–7; cf. Ps 40:6–8). The "yes" of the Son: "I have come to do your will", and the "yes" of Mary: "Let it be with me according to your word"—this double "yes"—becomes a single "yes", and thus the Word becomes flesh in Mary. In this double "yes" the obedience of the Son is embodied, and by her own "yes" Mary gives him that body. "Woman, what have I to do with you?" Ultimately, what each has to do with the other is found in this double "yes" which resulted in the Incarnation. The Lord's answer points to this point of profound unity. It is precisely to this that he points his Mother. Here, in their common "yes" to the will of the Father, an answer is found. We too need to learn always anew how to progress towards this point; there we will find the answer to our questions.

If we take this as our starting-point, we can now also understand the second part of Jesus' answer: "My hour has not yet come." Jesus never acts completely alone and never for the sake of pleasing others. The Father is always the starting-point of his actions, and this is what unites him to Mary, because she wished to make her request in this same unity of will with the Father. And so, surprisingly, after hearing Jesus' answer, which apparently refuses her request, she can simply say to the servants: "Do whatever he tells you" (Jn 2:5). Jesus is not a wonder-worker, he does not play games with his power in what is, after all, a private affair. No, he gives a sign, in which he proclaims his hour, the hour of the wedding feast, the hour of union between God and man.

He does not merely "make" wine, but transforms the human wedding feast into an image of the divine wedding feast, to which the Father invites us through the Son and in which he gives us every good thing, represented by the abundance of wine. The wedding feast becomes an image of that moment when Jesus pushed love to the utmost, let his body be rent and thus gave himself to us for ever, having become completely one with us—a marriage between God and man. The hour of the Cross, the hour which is the source of the Sacrament, in which he gives himself really to us in flesh and blood, puts his Body into our hands and our hearts, this is the hour of the wedding feast. Thus a momentary need is resolved in a truly divine manner, and the initial request is superabundantly granted. Jesus' hour has not yet arrived, but in the sign of the water changed into wine, in the sign of the festive gift, he even now anticipates that hour.

Jesus' "hour" is the Cross; his definitive hour will be his return at the end of time. He continually anticipates also this definitive hour in the Eucharist, in which, even now, he always comes to us. And he does this ever anew through the intercession of his Mother, through the intercession of the Church, which cries out to him in the Eucharistic prayers: "Come, Lord Jesus!" In the Canon of the Mass, the Church constantly prays for this "hour" to be anticipated, asking that he may come even now and be given to us. And so we want to let ourselves be guided by Mary, by the Mother of Grace of Altötting, by the Mother of all the faithful, towards the "hour" of Jesus. Let us ask him for the gift of a deeper knowledge and understanding of him. And may our reception of him not be reduced to the moment of communion alone. Jesus remains present in the sacred Host, and he awaits us constantly. Here in Altötting, the adoration of the Lord in the Eucharist has found a new location in the old treasury. Mary and Jesus go together. Through Mary we want to continue our converse with the Lord and to learn how to receive him better. Holy Mother of God, pray for us, just as at Cana you prayed for the bride and the bridegroom! Guide us towards Jesus—ever anew! Amen!

Homily, Altötting, September 11, 2006

On the following double-page spread: The crowning of a statue of Mary on World Day of the Sick on the Feast of Our Lady of Lourdes, February 2007

TO LOVE LIKE MARY

In her encounter with the gentle, respectful love of God, who awaits the free cooperation of his creature in order to bring about his saving plan, the Blessed Virgin was able to overcome all hesitation and, in view of this great and unprecedented plan, to entrust herself into his hands. With complete availability, interior openness and freedom, she allowed God to fill her with love, with his Holy Spirit. Mary, the simple woman, could thus receive within herself the Son of God and give to the world the Savior who had first given himself to her.

In today's celebration of the Eucharist, the Son of God has also been given to us. Those who have received Holy Communion, in a special way, carry the Risen Lord within themselves. Just as Mary bore him in her womb—a defenseless little child, totally dependent on the love of his Mother—so Jesus Christ, under the species of bread, has entrusted himself to us, dear brothers and sisters. Let us love this Jesus who gives himself so completely into our hands! Let us love him as Mary loved him! And let us bring him to others, just as Mary brought him to Elizabeth as the source of joyful exultation! The Virgin gave the Word of God a human body and thus enabled him to come into the world as a man. Let us give our own bodies to the Lord, and let them become ever more fully instruments of God's love, temples of the Holy Spirit! Let us bring Sunday, and its immense gift, into the world!

Let us ask Mary to teach us how to become, like her, inwardly free, so that in openness to God we may find true freedom, true life, genuine and lasting joy.

Angelus, Vienna, September 2007

Mother of Grace from Mariazell

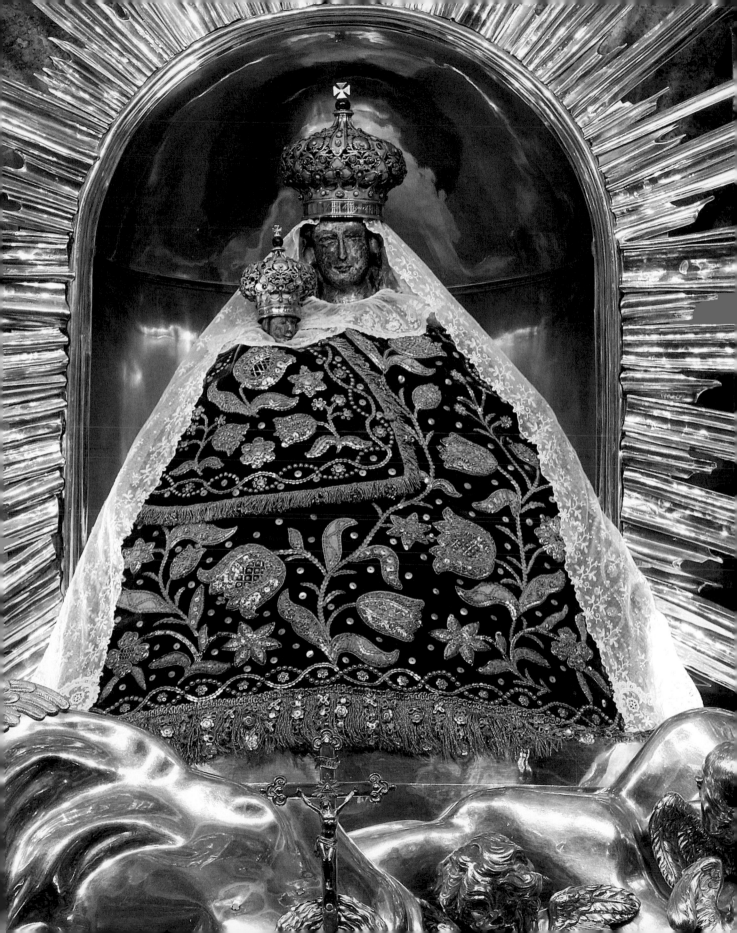

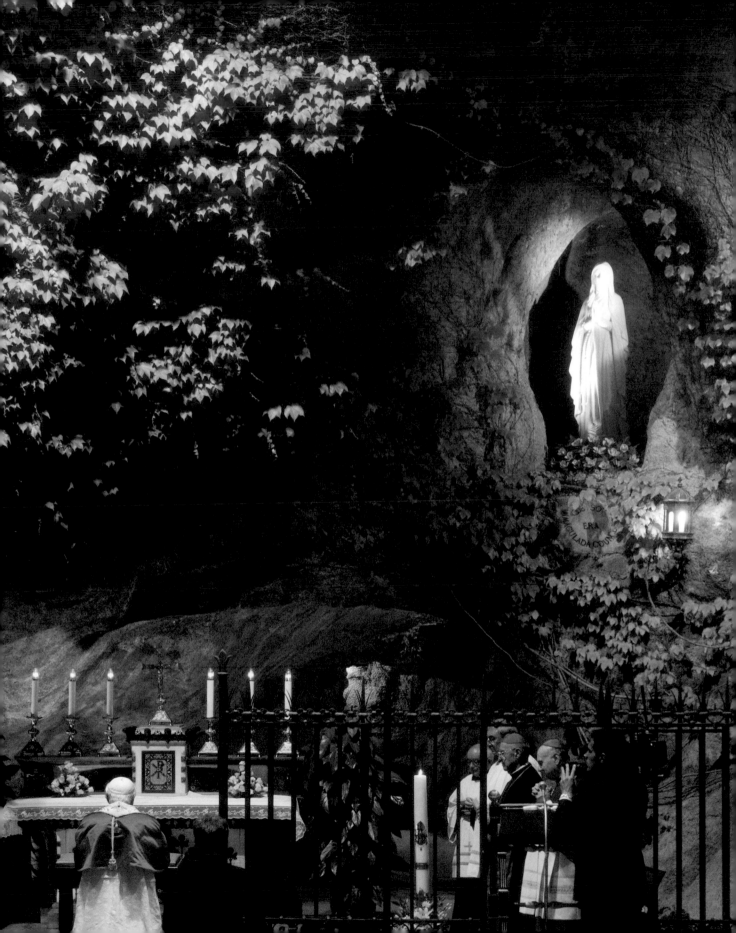

BRINGING JESUS TO OTHERS

Our Lady accompanies us every day in our prayers. During this special Year of the Eucharist in which we are living, Mary helps us above all to discover ever better the great sacrament of the Eucharist.

In his last Encyclical, *Ecclesia de Eucharistia*, our beloved Pope John Paul II presented her to us as "Woman of the Eucharist" throughout her life (cf. no. 53). "Woman of the Eucharist" through and through, beginning with her inner disposition: from the Annunciation, when she offered herself for the Incarnation of the Word of God, to the Cross and to the Resurrection; "Woman of the Eucharist" in the period subsequent to Pentecost, when she received in the Sacrament that Body which she had conceived and carried in her womb.

Today, in particular, we pause to meditate on the mystery of the Visitation of the Virgin to Saint Elizabeth. Mary went to see her elderly cousin Elizabeth, she whom everyone said was sterile but who instead had reached the sixth month of a pregnancy given to her by God (cf. Lk 1:36), and Mary was carrying in her womb the recently conceived Jesus. She was a young girl, but she was not afraid, for God was with her, within her.

In a certain way we can say that her journey was—and we like to emphasize it in this Year of the Eucharist—the first "Eucharistic procession" in history. Mary, living Tabernacle of God made flesh, is the Ark of the Covenant in whom the Lord visited and redeemed his people. Jesus' presence filled her with the Holy Spirit.

When she entered Elizabeth's house, her greeting was overflowing with grace: John leaped in his mother's womb, as if he were aware of the coming of the One whom he would one day proclaim to Israel. The children exulted, and the mothers exulted. This meeting, imbued with the joy of the Holy Spirit, is expressed in the canticle of the *Magnificat*.

Is this not also the joy of the Church, which ceaselessly welcomes Christ in the holy Eucharist and brings him into the world with the testimony of active charity, steeped in faith and hope? Yes, welcoming Jesus and bringing him to others is the true joy of Christians!

Dear brothers and sisters, let us follow and imitate Mary, a deeply Eucharistic soul, and our whole life can become a *Magnificat* (cf. *Ecclesia de Eucharistia*, no. 58), praise of God.

Address in the Vatican Gardens (photo) at the close of the month of Mary, May 31, 2005

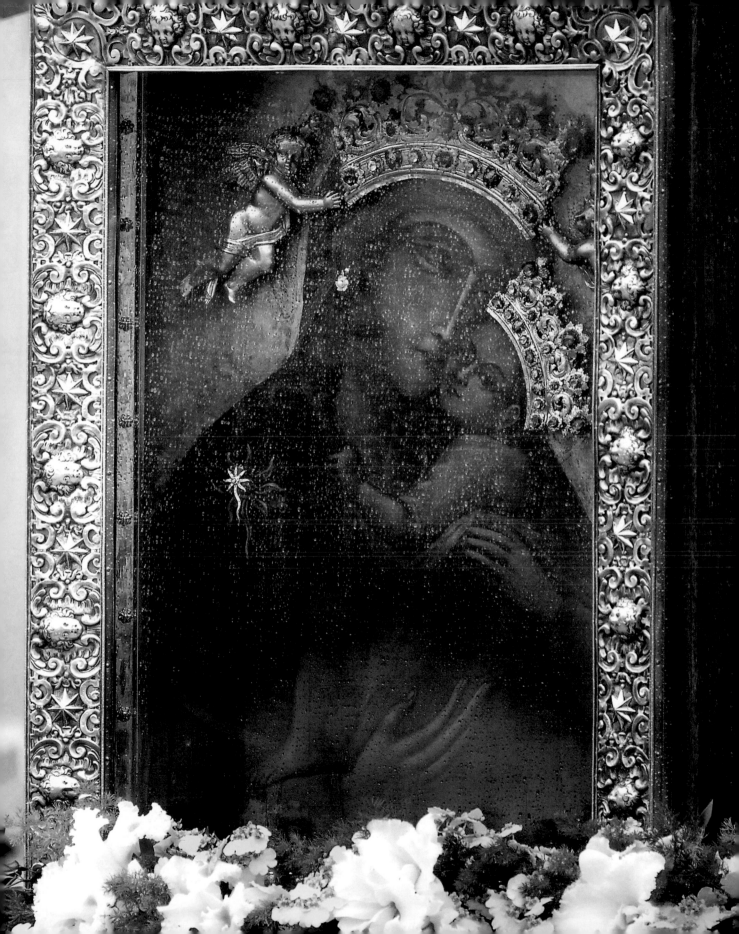

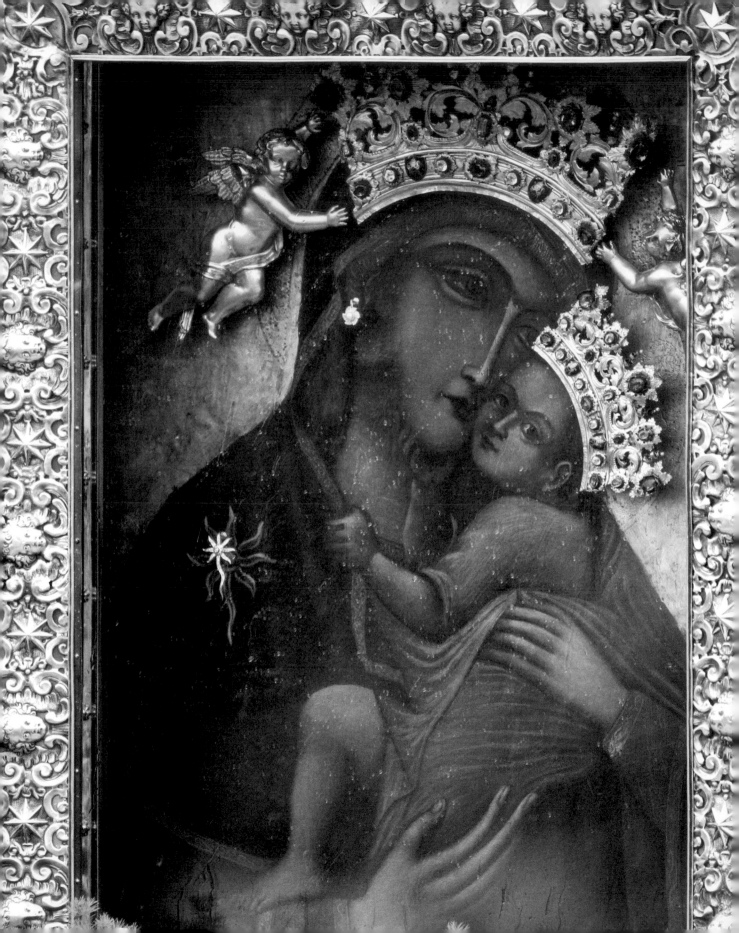

HEAVEN HAS A HEART

The Feast of the Assumption is a day of joy. God has won. Love has won. It has won life. Love has shown that it is stronger than death, that God possesses the true strength and that his strength is goodness and love.

Mary was taken up body and soul into Heaven: there is even room in God for the body. Heaven is no longer a very remote sphere unknown to us.

We have a Mother in Heaven. And the Mother of God, the Mother of the Son of God, is our Mother. He himself has said so. He made her our Mother when he said to the disciple and to all of us: "Behold, your Mother!" We have a Mother in Heaven. Heaven is open, Heaven has a heart. . . .

Mary is taken up body and soul into the glory of Heaven, and with God and in God she is Queen of Heaven and earth. And is she really so remote from us?

The contrary is true. Precisely because she is with God and in God, she is very close to each one of us. While she lived on this earth she could be close only to a few people. Being in God, who is close to us, actually "within" all of us, Mary shares in this closeness of God. Being in God and with God, she is close to each one of us, knows our hearts, can hear our prayers, can help us with her motherly kindness and has been given to us, as the Lord said, precisely as a "mother" to whom we can turn at every moment.

She always listens to us, she is always close to us and, being Mother of the Son, participates in the power of the Son and in his goodness. We can always entrust the whole of our lives to this Mother, who is not far from any one of us.

Homily on the Assumption of Mary,
Castel Gandolfo, August 15, 2005

Foregoing double-page spread: Pope Benedict XVI in the Piazza del Plebiscito in Naples, October 24, 2007

Left: Our Lady of Mount Carmel, Naples

THE *MAGNIFICAT*

In the Gospel we heard the *Magnificat*, that great poem inspired by the Holy Spirit that came from Mary's lips, indeed, from Mary's heart. This marvelous canticle mirrors the entire soul, the entire personality of Mary. We can say that this hymn of hers is a portrait of Mary, a true icon in which we can see her exactly as she is. I would like to highlight only two points in this great canticle.

It begins with the word "*Magnificat*": my soul "magnifies the Lord", that is, "proclaims the greatness of the Lord". Mary wanted God to be great in the world, great in her life and present among us all. She was not afraid that God might be a "rival" in our life, that with his greatness he might encroach on our freedom, our vital space. She knew that if God is great, we too are great. Our life is not oppressed but raised and expanded: it is precisely then that it becomes great in the splendor of God. . . .

Only if God is great is mankind also great. With Mary, we must begin to understand that this is so. We must not drift away from God but make God present; we must ensure that he is great in our lives. Thus, we too will become divine; all the splendor of the divine dignity will then be ours. . . . A second observation: Mary's poem—the *Magnificat*—is quite original; yet at the same time, it is a "fabric" woven throughout of "threads" from the Old Testament, of words of God.

Thus, we see that Mary was, so to speak, "at home" with God's Word, she lived on God's Word, she was penetrated by God's Word. To the extent that she spoke with God's words, she thought with God's words, her thoughts were God's thoughts, her words, God's words. She was penetrated by divine light, and this is why she was so resplendent, so good, so radiant with love and goodness. Mary lived on the Word of God; she was imbued with the Word of God. And the fact that she was immersed in the Word of God and was totally familiar with the Word also endowed her later with the inner enlightenment of wisdom.

Whoever thinks with God thinks well, and whoever speaks to God speaks well. They have valid criteria to judge all the things of the world. They become prudent, wise and at the same time good; they also become strong and courageous with the strength of God, who resists evil and fosters good in the world.

Homily on the Assumption of Mary,
Castel Gandolfo, August 15, 2005

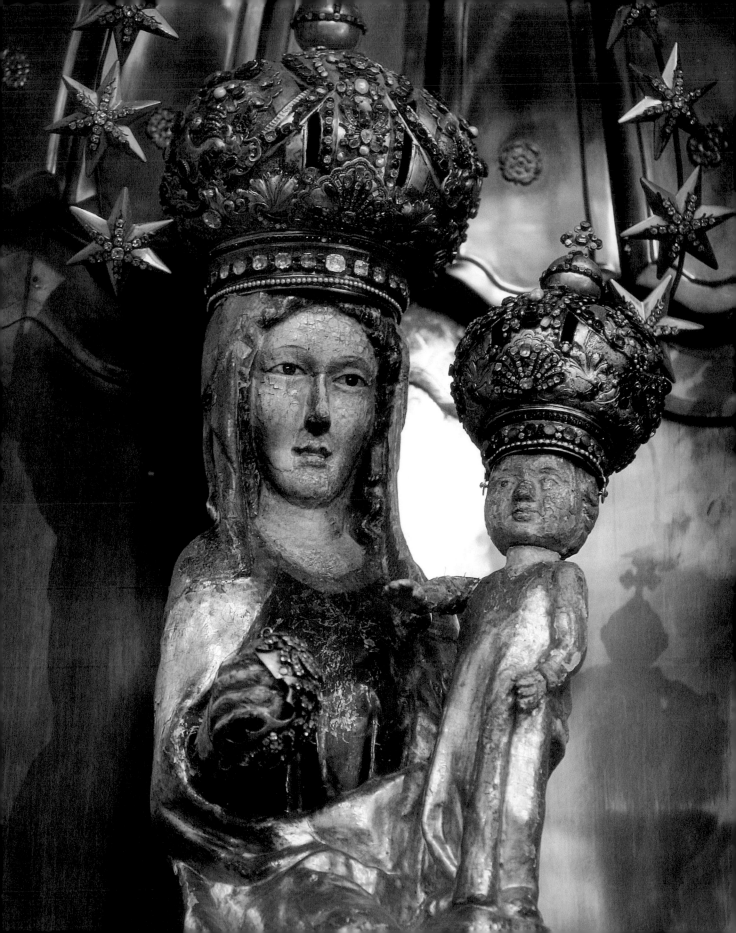

OUR HOME IS IN HEAVEN

Today, the Solemnity of the Assumption, we contemplate the mystery of Mary's passage from this world to Paradise: we celebrate, we could say, her "Pasch". Just as Christ rose from the dead with his glorious Body and ascended into Heaven, the Holy Virgin, completely united to him, was assumed into heavenly glory in her entire person. In this too, the Mother resembled her Son very closely, leading the way for us. Alongside Jesus, the new Adam, "first fruits" of those who have risen (cf. 1 Cor 15:20, 23), Our Lady, the new Eve, appears as "the beginning and image of the Church" (Preface), "sign of certain hope" for all Christians on their earthly pilgrimage (cf. *Lumen Gentium*, no. 68).

The Solemnity of the Assumption, so dear to popular tradition, serves as a useful occasion for all believers to meditate on the true sense and value of human existence in view of eternity. Dear brothers and sisters, Heaven is our final dwelling place; from there, Mary encourages us by her example to welcome God's will, so as not to allow ourselves to be seduced by the deceptive attraction to what is transitory and fleeting and not to give in to the temptations of selfishness and evil which extinguish the joy of life in the heart.

Angelus on the Assumption of Mary,
Castel Gandolfo, August 15, 2005

Miraculous statue in Maria Kulm, Bohemia

Foregoing double-page spread: Pope Benedict XVI and his private secretary, Monsignor Georg Gänswein, praying the Rosary in Lorenzago di Cadore, Dolomites

THE ETERNAL GOODNESS OF THE CREATOR SHINES FORTH IN MARY

Today, we are celebrating the Solemnity of the Immaculate Conception. It is a day of intense spiritual joy when we contemplate the Virgin Mary, "*high beyond all others, lowlier is none . . . the consummation planned by God's decree*", as is sung by the great poet Dante (*Paradise*, XXXIII, 3).

In Mary shines forth the eternal goodness of the Creator, who chose her in his plan of salvation to be the Mother of his Only-begotten Son; God, foreseeing his death, preserved her from every stain of sin (cf. Concluding Prayer). In this way, in the Mother of Christ and our Mother the vocation of every human being is perfectly fulfilled.

All men and women, according to Saint Paul, are called to be holy and blameless in God's sight, full of love (cf. Eph 1:4, 5).

Looking at Mary, how can we, her children, fail to let the aspiration to beauty, goodness and purity of heart be aroused in us? Her heavenly candor draws us to God, helping us to overcome the temptation to live a mediocre life composed of compromises with evil, and directs us decisively towards the authentic good that is the source of joy.

Angelus on the Solemnity of the Immaculate Conception, December 8, 2005

Statue of Mary in the pilgrimage church, Bogenberg, Bavaria

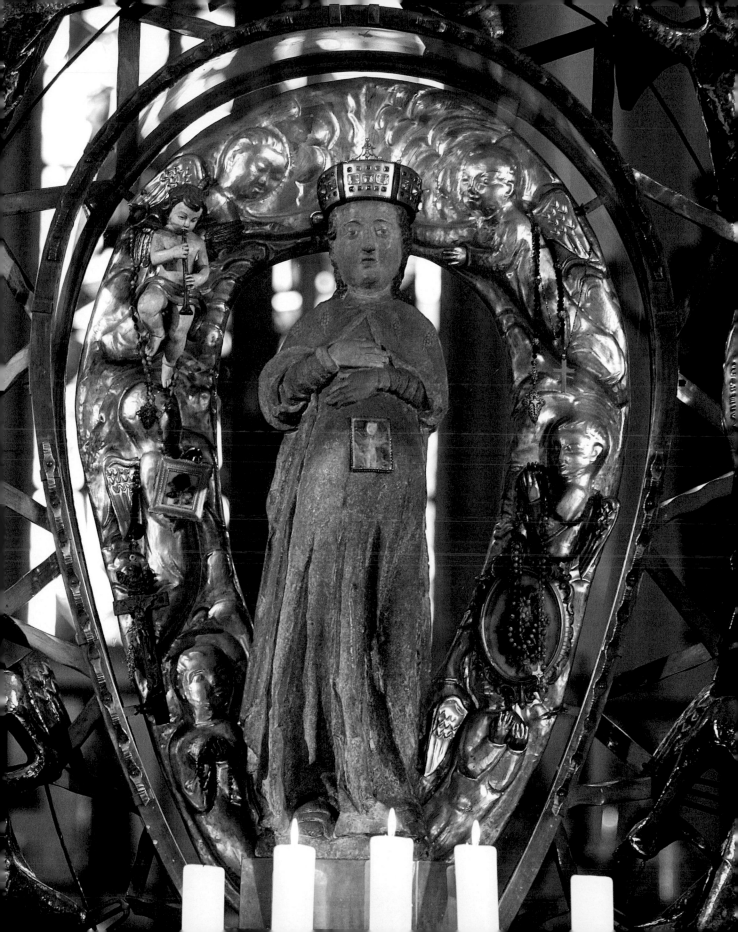

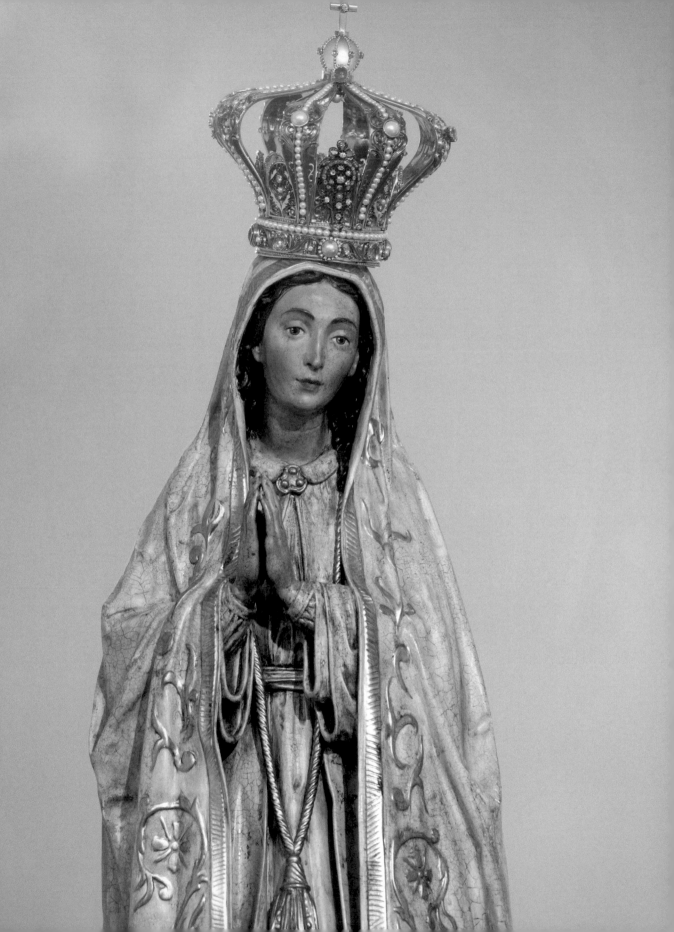

LET US FEEL YOUR CLOSENESS

Yes, we want to thank you, Virgin Mother of God and our most beloved Mother, for your intercession for the good of the Church. You, who in embracing the divine will without reserve were consecrated with all of your energies to the person and work of your Son, teach us to keep in our heart and to meditate in silence, as you did, upon the mysteries of Christ's life.

May you who reached Calvary, ever-deeply united to your Son who from the Cross gave you as Mother to the disciple John, also make us feel you are always close in each moment of our lives, especially in times of darkness and trial.

You, who at Pentecost, together with the Apostles in prayer, called upon the gift of the Holy Spirit for the newborn Church, help us to persevere in the faithful following of Christ. To you, a "sign of certain hope and comfort", we trustfully turn our gaze "until the day of the Lord shall come" (*Lumen Gentium*, no. 68).

You, Mary, are invoked with the insistent prayer of the faithful throughout the world so that you, exalted above all the angels and saints, will intercede before your Son for us, "until all families of peoples, whether they are honored with the title of Christian or whether they still do not know the Savior, may be happily gathered together in peace and harmony into one People of God, for the glory of the Most Holy and Undivided Trinity" (ibid., no. 69).

Tribute to the statue of the Immaculate Conception of the Virgin Mary, Piazza di Spagna, Rome, December 8, 2005

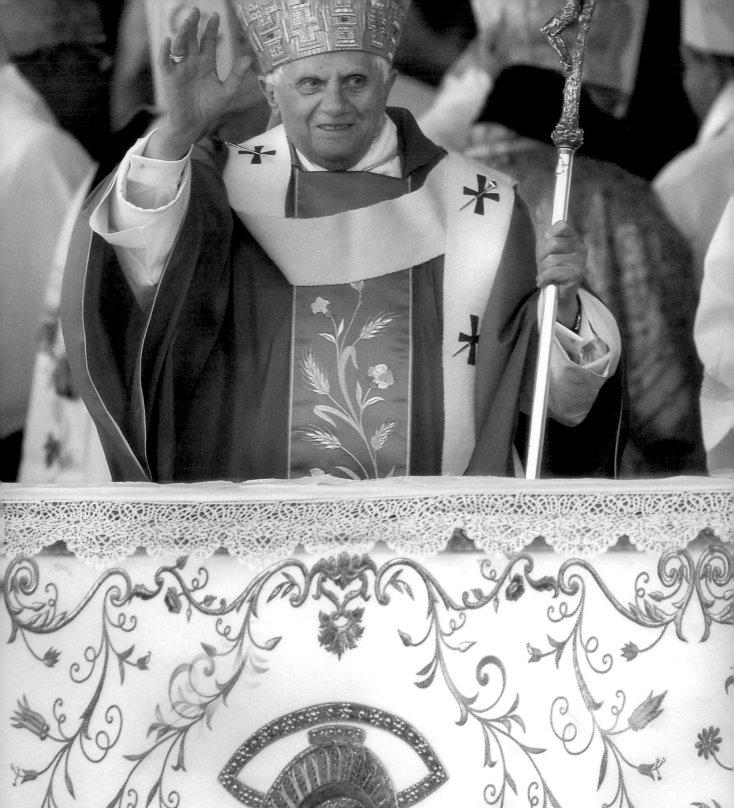

THE GREAT YES

At the end of the colloquium, Mary answered the Angel, "I am the servant of the Lord. Let it be done to me as you say." Thus, Mary anticipated the Our Father's third invocation: "Thy will be done." She said "yes" to God's great will, a will apparently too great for a human being; Mary said "yes" to this divine will, she placed herself within this will, placed her whole life with a great "yes" within God's will, and thus opened the world's door to God.

Adam and Eve, with their "no" to God's will, had closed this door. "Let God's will be done": Mary invites us too to say this "yes" which sometimes seems so difficult. We are tempted to prefer our own will, but she tells us: "Be brave, you too say: 'Your will be done', because this will is good." It might at first seem an unbearable burden, a yoke impossible to bear; but in reality, God's will is not a burden, God's will gives us wings to fly high, and thus we too can dare, with Mary, to open the door of our lives to God, the doors of this world, by saying "yes" to his will, aware that this will is the true good and leads us to true happiness. Let us pray to Mary, Comfort of the Afflicted, our Mother, the Mother of the Church, to give us the courage to say this "yes" and also to give us this joy of being with God and to lead us to his Son, to true life.

Homily, December 18, 2005

Pope Benedict XVI at the Mass in the Piazza del Plebiscito, Naples, October 21, 2007

Following double-page spread: Statue of Our Lady of Lourdes, Saint Peter's Basilica;
Pope Benedict XVI at Vespers on the First Sunday of Advent, November 26, 2005

MARY, MOTHER OF DIVINE LOVE

Those who draw near to God do not withdraw from men, but rather become truly close to them. In no one do we see this more clearly than in Mary. The words addressed by the crucified Lord to his disciple—to John and through him to all disciples of Jesus: "Behold, your mother!" (Jn 19:27)—are fulfilled anew in every generation. Mary has truly become the Mother of all believers. Men and women of every time and place have recourse to her motherly kindness and her virginal purity and grace, in all their needs and aspirations, their joys and sorrows, their moments of loneliness and their common endeavors. They constantly experience the gift of her goodness and the unfailing love which she pours out from the depths of her heart. The testimonials of gratitude, offered to her from every continent and culture, are a recognition of that pure love which is not self-seeking but simply benevolent. At the same time, the devotion of the faithful shows an infallible intuition of how such love is possible: it becomes so as a result of the most intimate union with God, through which the soul is totally pervaded by him—a condition which enables those who have drunk from the fountain of God's love to become in their turn a fountain from which "flow rivers of living water" (Jn 7:38). Mary, Virgin and Mother, shows us what love is and whence it draws its origin and its constantly renewed power. To her we entrust the Church and her mission in the service of love:

Holy Mary, Mother of God,
you have given the world its true light,
Jesus, your Son—the Son of God.
You abandoned yourself completely
to God's call
and thus became a wellspring
of the goodness which flows forth
from him.
Show us Jesus. Lead us to him.
Teach us to know and love him,
so that we too can become
capable of true love
and be fountains of living water
in the midst of a thirsting world.

Encyclical *Deus caritas est* (*God Is Love*),
December 25, 2005

Miraculous marble statue of Ettal

THE FIRST DISCIPLE

The first person to be associated with Christ on the path of obedience, proven faith and shared suffering was his Mother, Mary. The Gospel text portrays her in the act of offering her Son: an unconditional offering that involves her in the first person.

Mary is the Mother of the One who is "the glory of [his] people Israel" and a "light for revelation to the Gentiles", but also "a sign that is spoken against" (cf. Lk 2:32, 34). And in her immaculate soul, she herself was to be pierced by the sword of sorrow, thus showing that her role in the history of salvation did not end in the mystery of the Incarnation but was completed in loving and sorrowful participation in the death and Resurrection of her Son.

Bringing her Son to Jerusalem, the Virgin Mother offered him to God as a true Lamb who takes away the sins of the world. She held him out to Simeon and Anna as the proclamation of redemption; she presented him to all as a light for a safe journey on the path of truth and love.

Homily on the Feast of the Presentation of the Lord, February 2, 2006

Foregoing double-page spread: Sanctuary of the Madonna of Divine Love, Rome, May 1, 2006

Picture on the right: The Mother Thrice Admirable of Schönstatt

Following double-page spread: Benedict XVI at Angelus, Valle d'Aosta, July 2006

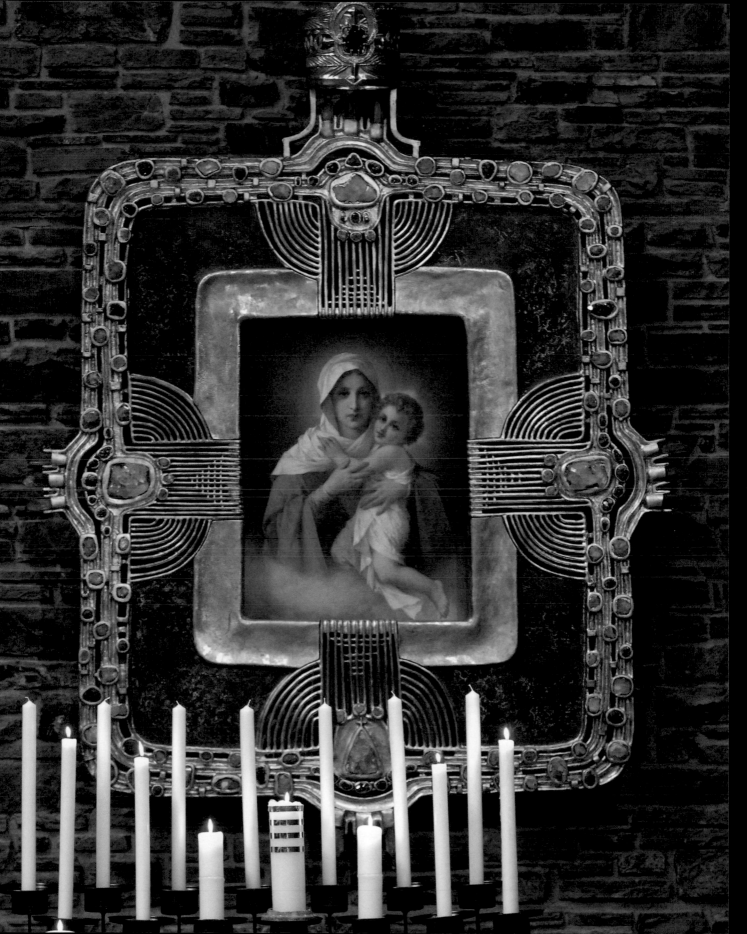

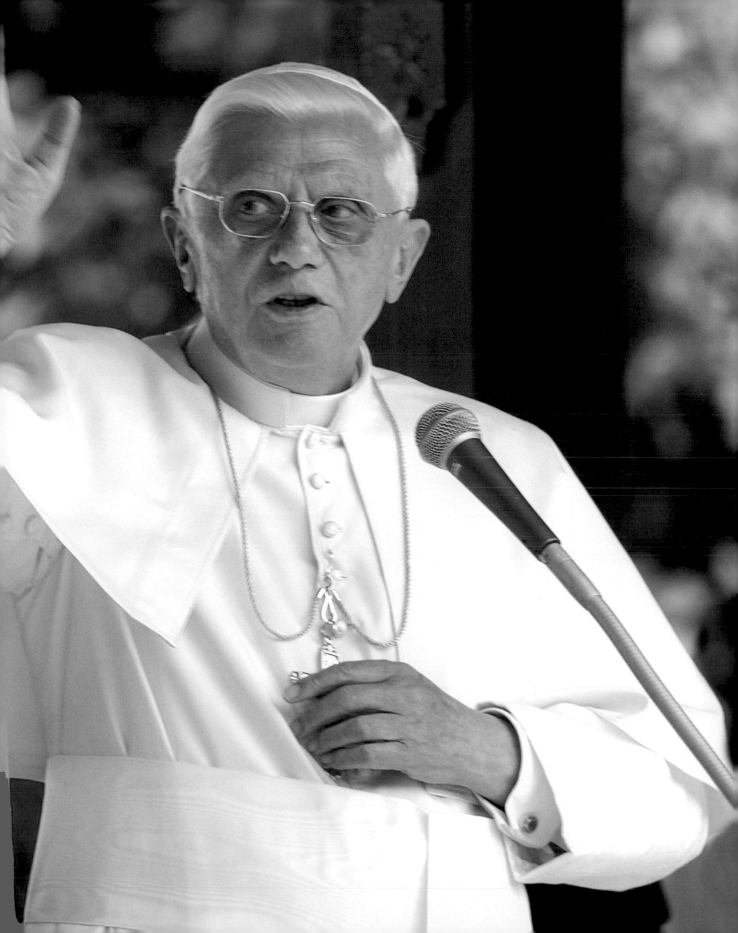

THE MOTHERLY MEDIATION OF MARY

Fourteen years ago, February 11, the liturgical Memorial of Our Lady of Lourdes, became World Day of the Sick. We all know that the Virgin expressed God's tenderness for the suffering in the Grotto of Massabielle. This tenderness, this loving concern, is felt in an especially lively way in the world precisely on the day of the Feast of Our Lady of Lourdes, representing in the liturgy, and especially in the Eucharist, the mystery of Christ, Redeemer of Man, of whom the Immaculate Virgin is the first fruit.

In presenting herself to Bernadette as the Immaculate Conception, Mary Most Holy came to remind the modern world, which was in danger of forgetting it, of the primacy of divine grace, which is stronger than sin and death. And so it was that the site of her apparition, the Grotto of Massabielle at Lourdes, became a focal point that attracts the entire People of God, especially those who feel oppressed and suffering in body and spirit.

"Come to me all of you who labor and are heavy laden, and I will give you rest" (Mt 11:28), Jesus said. In Lourdes he continues to repeat this invitation, with the motherly mediation of Mary, to all those who turn to him with trust. . . .

With profound faith let us present to her our human condition, our illnesses, a sign of neediness that is common to us all as we journey on in this earthly pilgrimage to be saved by her Son, Jesus Christ. May Mary keep our hope alive so that, faithful to Christ's teaching, we renew the commitment to relieving our brethren in their sickness. May the Lord ensure that no one is alone or abandoned in a time of need, but, on the contrary, can live illness too in accordance with human dignity.

Address on the World Day of the Sick, February 11, 2006

Statue of Mary in the Grotto of Massabielle, Lourdes

TO LISTEN TO CHRIST, LIKE MARY

The Virgin Mary herself, among all human creatures the closest to God, still had to walk day after day in a pilgrimage of faith (cf. *Lumen Gentium*, no. 58), constantly guarding and meditating in her heart on the Word that God addressed to her through Holy Scripture and through the events of the life of her Son, in whom she recognized and welcomed the Lord's mysterious voice.

And so, this is the gift and duty for each one of us during the season of Lent: to listen to Christ, like Mary. To listen to him in his Word, contained in Sacred Scripture. To listen to him in the events of our lives, seeking to decipher in them the messages of Providence. Finally, to listen to him in our brothers and sisters, especially in the lowly and the poor, to whom Jesus himself demands our concrete love. To listen to Christ and obey his voice: this is the principal way, the only way, that leads to the fullness of joy and of love.

Angelus, March 12, 2006

Miraculous statue in Maria Taferl, Austria

MARY, IMAGE OF THE CHURCH

In the Incarnation of the Son of God, in fact, we recognize the origins of the Church. Everything began from there. Every historical realization of the Church and every one of her institutions must be shaped by that primordial wellspring. They must be shaped by Christ, the incarnate Word of God. It is he that we are constantly celebrating: Emmanuel, God-with-us, through whom the saving will of God the Father has been accomplished. And yet—today of all days we contemplate this aspect of the mystery—the divine wellspring flows through a privileged channel: the Virgin Mary.

Saint Bernard speaks of this using the eloquent image of *aquaeductus* (cf. *Sermo in Nativitate B.V. Mariae*: PL 183:437–48). In celebrating the Incarnation of the Son, therefore, we cannot fail to honor his Mother. The Angel's proclamation was addressed to her; she accepted it, and when she responded from the depths of her heart: "Here I am . . . let it be done to me according to your word" (Lk 1:38), at that moment the eternal Word began to exist as a human being in time.

From generation to generation, the wonder evoked by this ineffable mystery never ceases. Saint Augustine imagines a dialogue between himself and the Angel of the Annunciation, in which he asks: "Tell me, O Angel, why did this happen in Mary?" The answer, says the Messenger, is contained in the very words of the greeting: "Hail, full of grace" (cf. *Sermo* 291:6).

In fact, the Angel, "appearing to her", does not call her by her earthly name, Mary, but by her divine name, as she has always been seen and characterized by God:

"Full of grace—*gratia plena*", which in the original Greek is κεχαριτωμένη, "full of grace", and the grace is none other than the love of God; thus, in the end, we can translate this word: "beloved" of God (cf. Lk 1:28). Origen observes that no such title had ever been given to a human being and that it is unparalleled in all of Sacred Scripture (cf. *In Lucam* 6:7).

It is a title expressed in passive form, but this "passivity" of Mary, who has always been and is for ever "loved" by the Lord, implies her free consent, her personal and original response: in *being loved*, in receiving the gift of God, Mary is fully *active*, because she accepts with personal generosity the wave of God's love poured out upon her. In this too, she is the perfect disciple of her Son, who realizes the fullness of his freedom and thus exercises the freedom through obedience to the Father.

In the Second Reading, we heard the wonderful passage in which the author of the Letter to the Hebrews interprets Psalm 39 in the light of Christ's Incarnation: "When Christ came into the world, he said: . . . 'Here I am, I have come to do your will, O God'" (Heb 10:5–7). Before the mystery of these two "Here I am" statements, the "Here I am" of the Son and the "Here I am" of the Mother, each of which is reflected in the other, forming a single *Amen* to God's loving will, we are filled with wonder and thanksgiving, and we bow down in adoration. . . .

The icon of the Annunciation, more than any other, helps us to see clearly how everything in the Church goes back to that mystery of Mary's acceptance of the divine Word, by which, through the action of the Holy Spirit, the Covenant between God and humanity was perfectly sealed. Everything in the Church, every institution and ministry, including that of Peter and his Successors, is "included" under the Virgin's mantle, within the grace-filled horizon of her "yes" to God's will. This link with Mary naturally evokes a strong affective resonance in all of us, but first of all it has an objective value. Between Mary and the Church there is indeed a connatural relationship that was strongly emphasized by the Second Vatican Council in its felicitous decision to place the treatment of the Blessed Virgin at the conclusion of the Constitution on the Church, *Lumen Gentium*.

. . . The first thing that Mary did after receiving the Angel's message was to go "in haste" to the house of her cousin Elizabeth in order to be of service to her (cf. Lk 1:39). The Virgin's initiative was one of genuine charity; it was humble and courageous, motivated by faith in God's Word and the inner promptings of the Holy Spirit. Those who love forget about themselves and place themselves at the service of their neighbor. Here we have the image and model of the Church! Every Ecclesial Community, like the Mother of Christ, is called to accept with total generosity the mystery of God who comes to dwell within her and guides her steps in the ways of love.

Homily on the Annunciation to Mary,
March 25, 2006

Following double-page spread: Miraculous statue in Andechs

MARY, MOTHER AND TEACHER

In the days that followed the Lord's Resurrection, the Apostles stayed together, comforted by Mary's presence, and after the Ascension they persevered with her in prayerful expectation of Pentecost. Our Lady was a Mother and teacher to them, a role that she continues to play for Christians of all times.

Every year, at Eastertide, we relive this experience more intensely, and perhaps, precisely for this reason, popular tradition has dedicated to Mary the month of May, which normally falls between Easter and Pentecost. Consequently, this month which we begin tomorrow helps us to rediscover the maternal role that she plays in our lives so that we may always be docile disciples and courageous witnesses of the Risen Lord.

Let us entrust to Mary the needs of the Church and of the whole world, especially at this time which is marked by so many shadows.

Regina Caeli, April 30, 2006

Right: Veneration of a statue of Mary in Saint Peter's Basilica on the feast day of Our Lady of Lourdes, February 11, 2006

Following double-page spread: Pope Benedict XVI at the Angelus in Les Combes, Valle d'Aosta, July 2005

THE JOYFUL MYSTERY

We have recited the Holy Rosary going through the five "Joyful" Mysteries, which portray to the eyes of the heart the beginnings of our salvation, from Jesus' conception in the Virgin Mary's womb, brought about by the Holy Spirit, until he was found in the temple of Jerusalem when he was twelve years old, listening to the teachers and asking them questions.

We have repeated and made our own the Angel's words: "Hail, Mary, full of grace, the Lord is with you!", and also the words with which Saint Elizabeth welcomed the Virgin who went with haste to help and serve her: "Blessed are you among women, and blessed is the fruit of your womb!"

We have contemplated the docile faith of Mary, who trusted in God without reserve and put herself entirely in his hands. Like the shepherds, we too have felt close to the Child Jesus lying in the manger and recognized and adored him as the eternal Son of God, who, through love, became our brother, hence, our one Savior.

We too entered the temple with Mary and Joseph, to offer the Child to God and to carry out the rite of purification: and here, together with salvation, we felt ourselves anticipating, in the words of the elderly Simeon, the contradictory sign of the Cross and the sword that beneath the Cross of the Son was to pierce the Mother's soul, thereby making her not only the Mother of God but also Mother of us all. . . .

Thus, full light is shed on the bond that united Mary with the Holy Spirit from the very beginning of her existence when, as she was being conceived, the Spirit, the eternal Love of the Father and of the Son, made his dwelling within her and preserved her from any shadow of sin; then again, when the same Spirit brought the Son of God into being in her womb; and yet again

Pope Benedict XVI praying the Rosary with students, March 11, 2006

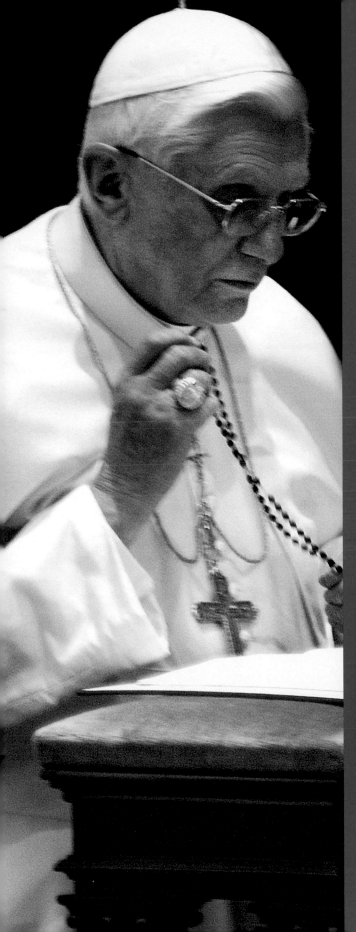

when, with the grace of the Spirit, Mary's own words were fulfilled through the whole span of her life: "Behold, I am the handmaid of the Lord"; and lastly, when, by the power of the Holy Spirit, Mary was taken up physically to be beside the Son in the glory of God the Father.

"Mary", I wrote in the Encyclical *Deus Caritas Est*, "is a woman who loves. . . . As a believer who in faith thinks with God's thoughts and wills with God's will, she cannot fail to be a woman who loves" (no. 41). Yes, dear brothers and sisters, Mary is the fruit and sign of the love God has for us, of his tenderness and mercy. Therefore, together with our brothers in the faith of all times and all places, we turn to her in our needs and hopes, in the joyful and sorrowful events of life.

Address at the beginning of Mary's month,
May 1, 2006

61

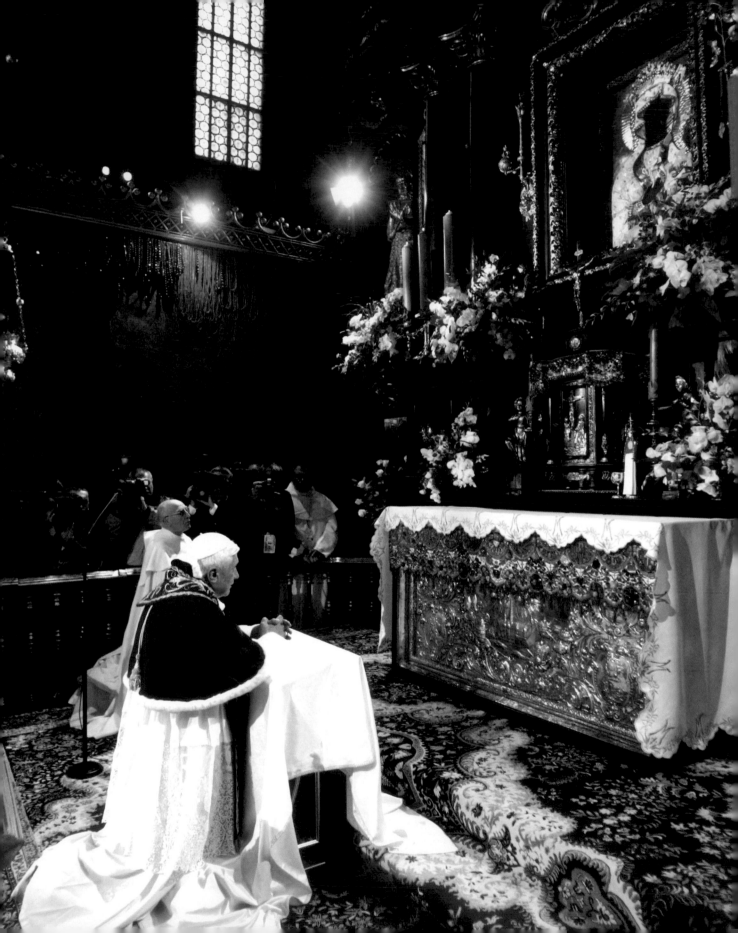

WITH MARY IN PRAYER

Just as the Apostles together with Mary "went to the upper room" and there "with one accord devoted themselves to prayer" (Acts 1:12, 14), so we too have come together today at Jasna Góra, which for us at this hour is the "upper room" where Mary, the Mother of the Lord, is among us. Today it is she who leads our meditation; she teaches us how to pray. Mary shows us how to open our minds and our hearts to the power of the Holy Spirit, who comes to us so as to be brought to the whole world. . . .

My dear friends, we need a moment of silence and recollection to place ourselves in her school, so that she may teach us how to live from faith, how to grow in faith, how to remain in contact with the mystery of God in the ordinary, everyday events of our lives. With feminine tact and with "the ability to combine penetrating intuition with words of support and encouragement"

(John Paul II, *Redemptoris Mater*, no. 46), Mary sustained the faith of Peter and the Apostles in the Upper Room, and today she sustains my faith and your faith. . . .

In the Upper Room the Apostles did not know what awaited them. They were afraid and worried about their own future. They continued to marvel at the death and Resurrection of Jesus and were in anguish at being left on their own after his Ascension into Heaven. Mary, "she who believed in the fulfillment of the Lord's words" (cf. Lk 1:45), assiduous in prayer alongside the Apostles, taught perseverance in the faith. By her own attitude she convinced them that the Holy Spirit, in his wisdom, knew well the path on which he was leading them and that consequently they could place their confidence in God, giving themselves to him unreservedly, with their talents, their limitations and their future. . . .

Pope Benedict XVI in the sanctuary of Częstochowa

So much can be gained by reflecting on the way Mary learned from Jesus! From her very first "*fiat*", through the long, ordinary years of the hidden life, as she brought up Jesus, or when at Cana in Galilee she asked for the first sign, or when finally on Calvary, by the Cross, she looked on Jesus, she "learned" him moment by moment. Firstly in faith and then in her womb, she received the Body of Jesus and then gave birth to him. Day after day, enraptured, she adored him. She served him with solicitous love, singing the *Magnificat* in her heart. . . . Mirror yourselves in her heart. Remain in her school!

When the Apostles, filled with the Holy Spirit, went out to the whole world proclaiming the Gospel, one of them, John, the Apostle of love, took Mary into his home (cf. Jn 19:27). It was precisely because of his profound bond with Jesus and with Mary that he could so effectively insist on the truth that "God is love" (1 Jn 4:8, 16). These were the words that I placed at the beginning of the first Encyclical of my Pontificate: *Deus caritas est*! This is the most important, most central truth about God. To all for whom it is difficult to believe in God, I say again today: "God is love." Dear friends, be witnesses to this truth. You will surely be so if you place yourselves in the school of Mary. Beside her you will experience for yourselves that God is love, and you will transmit this message to the world with the richness and the variety that the Holy Spirit will know how to enkindle.

Address in Częstochowa, Poland, May 26, 2006

Black Madonna of Częstochowa

Following double-page spread: Marian column in Lourdes; Pope Benedict XVI venerating the Marian column in the Piazza di Spagna, Rome, December 8, 2007

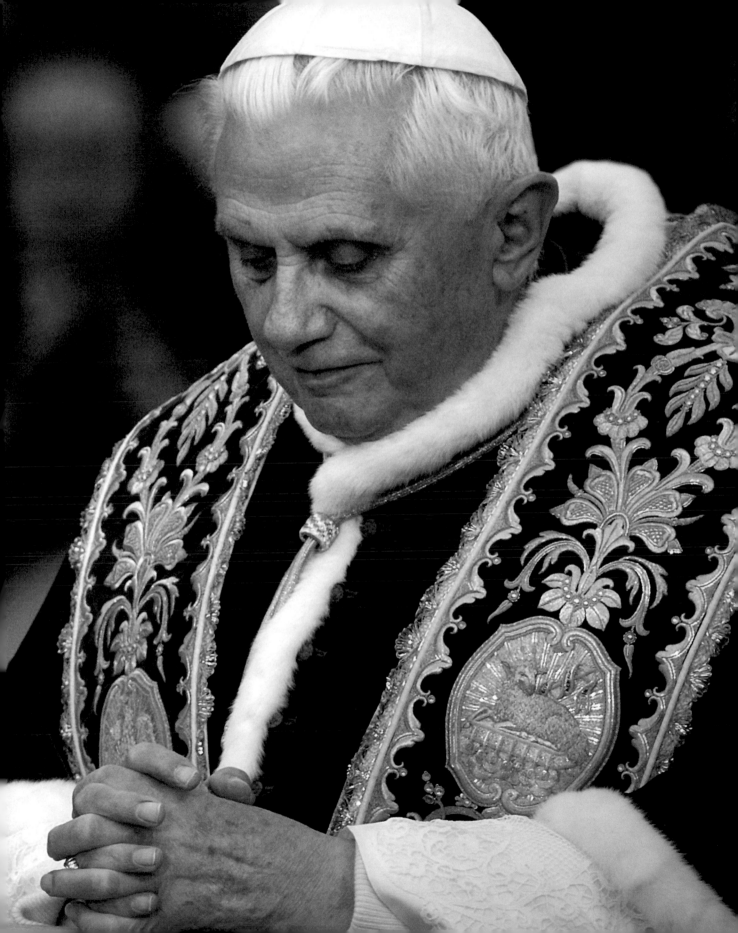

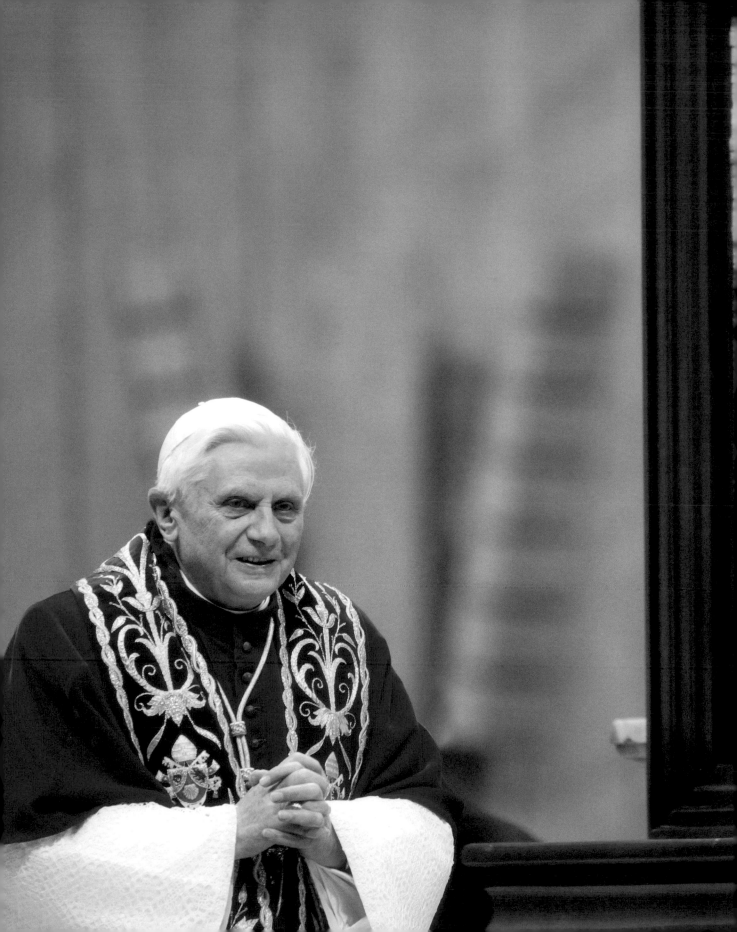

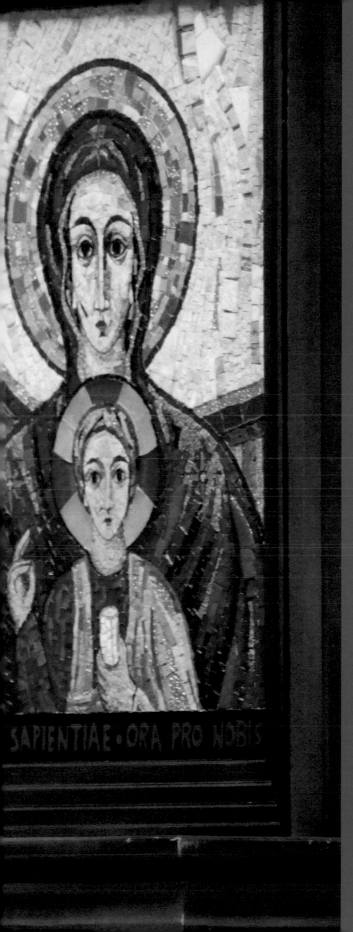

SAPIENTIAE · ORA PRO NOBIS

MARY,
SEAT OF WISDOM

Learn from the Virgin Mary, the first person to contemplate the humanity of the incarnate Word, the humanity of Divine Wisdom. In the Baby Jesus, with whom she had infinite and silent conversations, she recognized the human Face of God, so that the mysterious Wisdom of the Son was impressed on the Mother's mind and heart. So it was that Mary became the "Seat of Wisdom" and with this title is venerated in particular by the Roman Academic Community.

A special icon is dedicated to the *Sedes Sapientiae*. From Rome it has already visited various countries on a pilgrimage to university institutions. It is present here today, so that it may be passed on from the delegation which has come here from Bulgaria to the one which has come from Albania.

I greet with affection the representatives of both these nations and express the wish that *per Mariam* their respective academic communities may advance ever further in their search for truth and goodness, in the light of Divine Wisdom.

Address, December 14, 2006

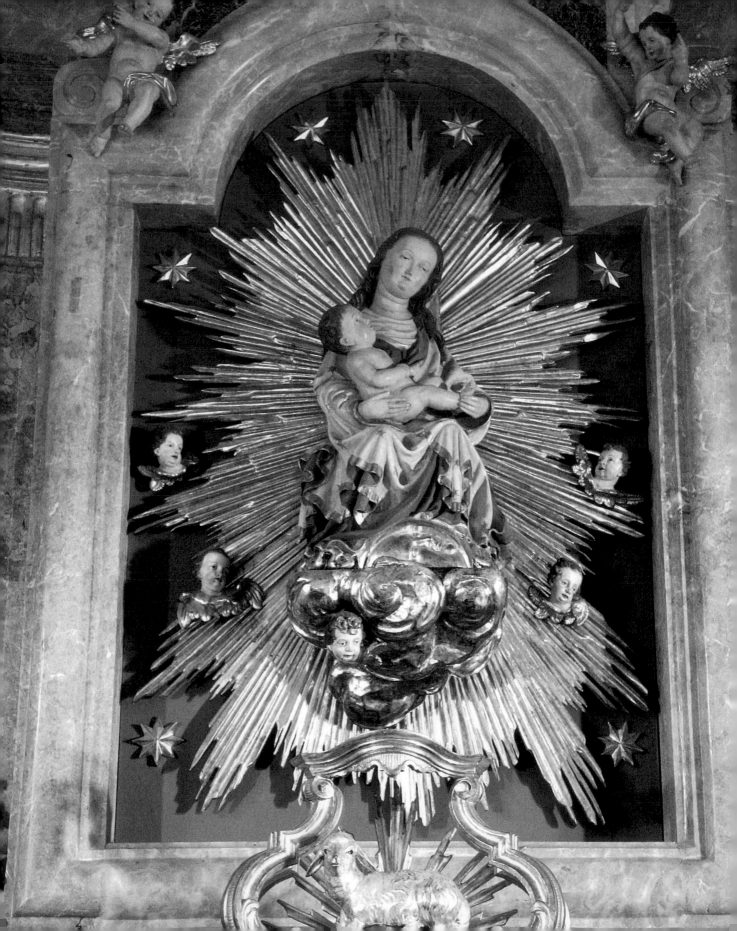

VISITATION OF MARY

I would also like to express to Mary my gratitude for the support she offers me in my daily service to the Church. I know that I can count on her help in every situation; indeed, I know that she foresees with maternal intuition all her children's needs and intervenes effectively to sustain them: this has been the experience of the Christian people ever since its first steps in Jerusalem.

On today's Feast of the Visitation, as in every passage of the Gospel, we see Mary docile to the divine plan and with an attitude of provident love for the brethren. In fact, the humble maiden from Nazareth, still amazed at what the Angel Gabriel had announced to her— that is, that she would be the Mother of the promised Messiah—learned that in her old age her elderly kinswoman Elizabeth had also conceived a son.

She immediately set out with haste for the house of her cousin, the Evangelist notes (cf. Lk 1:39), to offer her help at a time of special need. How can we fail to see that the hidden protagonist in the meeting between the young Mary and the by-then elderly Elizabeth is Jesus? Mary bears him in her womb as in a sacred tabernacle and offers him as the greatest gift to Zechariah, to Elizabeth, his wife, and also to the infant developing in her womb. "Behold", the mother of John the Baptist says, "when the voice of your greeting came to my ears, the babe in my womb leaped for joy" (Lk 1:44).

Whoever opens his heart to the Mother encounters and welcomes the Son and is pervaded by his joy. True Marian devotion never obscures or diminishes faith and love for Jesus Christ Our Savior, the one Mediator between God and mankind. On the contrary, entrustment to Our Lady is a privileged path, tested by numerous saints, for a more faithful following of the Lord. Consequently, let us entrust ourselves to her with filial abandonment!

Address at the close of Mary's month, May 31, 2006

THE MASTERPIECE OF
THE MOST HOLY TRINITY

The Virgin Mary, among all creatures, is a masterpiece of the Most Holy Trinity. In her humble heart full of faith, God prepared a worthy dwelling place for himself in order to bring to completion the mystery of salvation. Divine Love found perfect correspondence in her, and in her womb the Only-begotten Son was made man. Let us turn to Mary with filial trust, so that with her help we may progress in love and make our life a hymn of praise to the Father through the Son in the Holy Spirit.

Angelus, June 11, 2006

The Church at prayer has seen in this humble queen interceding with all her heart for her suffering people, a prefigurement of Mary, whom her Son has given to us all as our Mother; a prefigurement of the Mother who protects by her love God's family on its earthly pilgrimage. Mary is the image and model of all mothers, of their great mission to be guardians of life, of their mission to be teachers of the art of living and of the art of loving.

Homily for World Family Day in Valencia, Spain, July 9, 2006

Pope Benedict XVI preaches in Valencia next to the Virgen de los Desemparados (Our Lady of the Abandoned Ones), July 9, 2006

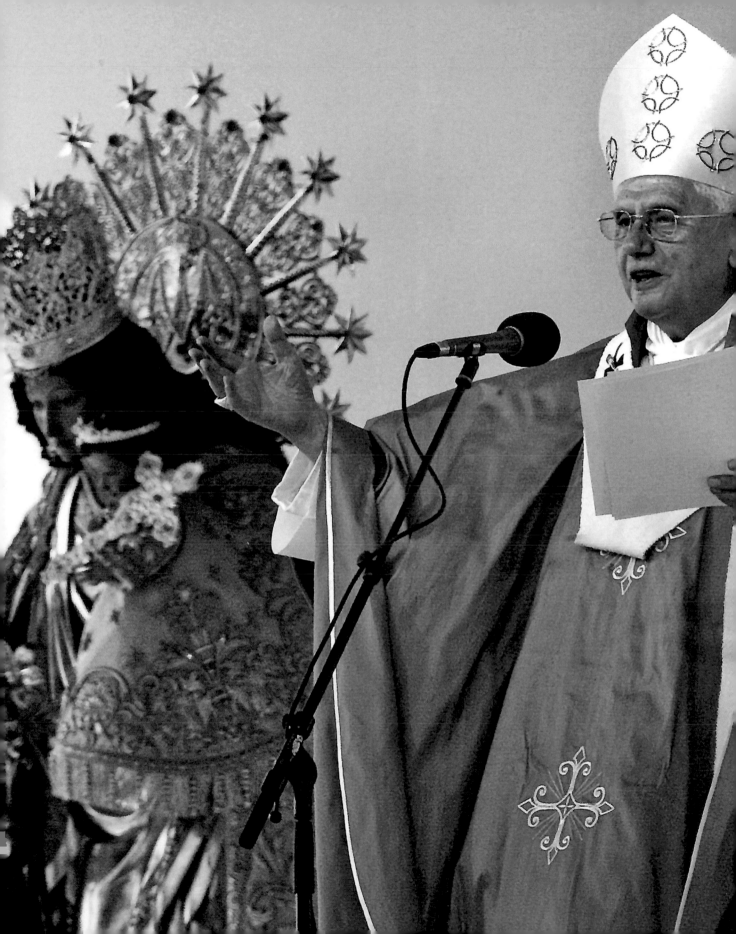

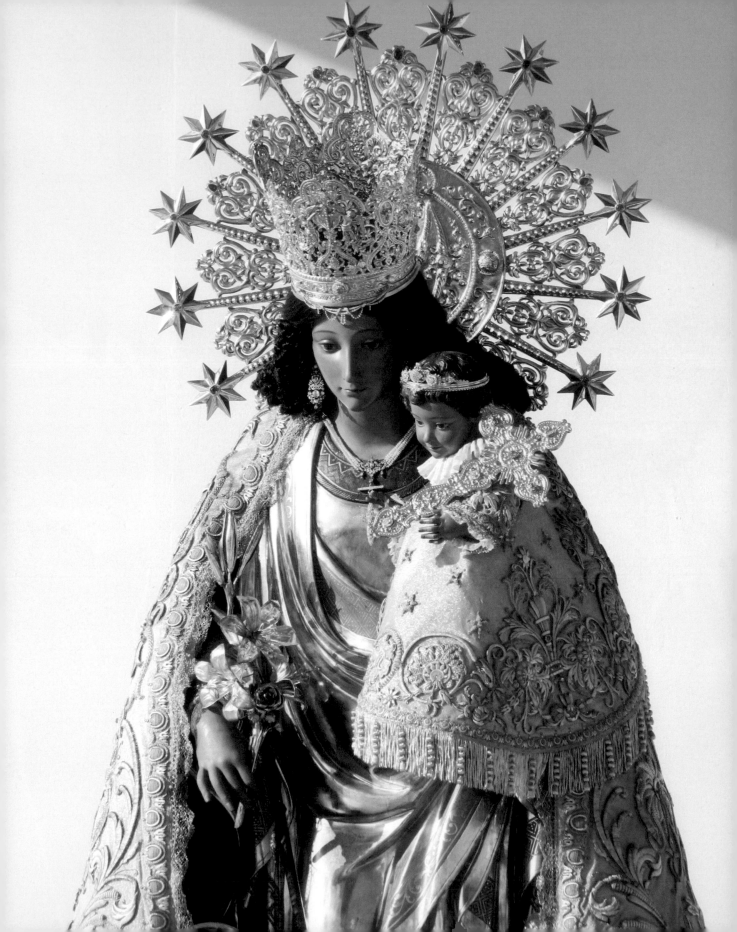

THE CHURCH'S PRAISE OF MARY

In the *Magnificat*, the great hymn of Our Lady that we have just heard in the Gospel, we find some surprising words. Mary says: "Henceforth all generations will call me blessed." The Mother of the Lord prophesies the Marian praise of the Church for all of the future, the Marian devotion of the People of God until the end of time. In praising Mary, the Church did not invent something "adjacent" to Scripture: she responded to this prophecy which Mary made at that moment of grace.

And Mary's words were not only personal, perhaps arbitrary words. Elizabeth, filled with the Holy Spirit, as Saint Luke said, exclaimed with a loud cry: "Blessed is she who believed. . . ." And Mary, also filled with the Holy Spirit, continues and completes what Elizabeth said, affirming: "All generations will call me blessed." It is a real prophecy, inspired by the Holy Spirit, and in venerating Mary, the Church responds to a command of the Holy Spirit; she does what she has to do.

We do not praise God sufficiently by keeping silent about his saints, especially Mary, "the Holy One" who became his dwelling place on earth. The simple and multiform light of God appears to us exactly in its variety and richness only in the countenance of the saints, who are the true mirrors of his light. And it is precisely by looking at Mary's face that we can see more clearly than in any other way the beauty, goodness and mercy of God. In her face we can truly perceive the divine light.

"All generations will call me blessed." We can praise Mary, we can venerate Mary, for she is "blessed", she is blessed for ever. And this is the subject of this Feast. She is blessed because she is united to God; she lives with God and in God. On the eve of his Passion, taking leave of his disciples, the Lord said: "In my Father's house are many rooms. . . .I go to prepare a place for you." By saying, "I am the handmaid of the Lord; let it be done to me according to your word", Mary prepared God's dwelling here on earth; with her body and soul, she became his dwelling place and thereby opened the earth to Heaven.

Homily on the Assumption of Mary,
Castel Gandolfo, August 15, 2006

Our Lady of the Abandoned Ones, Valencia

Following double-page spread: Veneration of the Mother of God on the Assumption of Mary, Maria Vesperbild, Bavarian Swabia

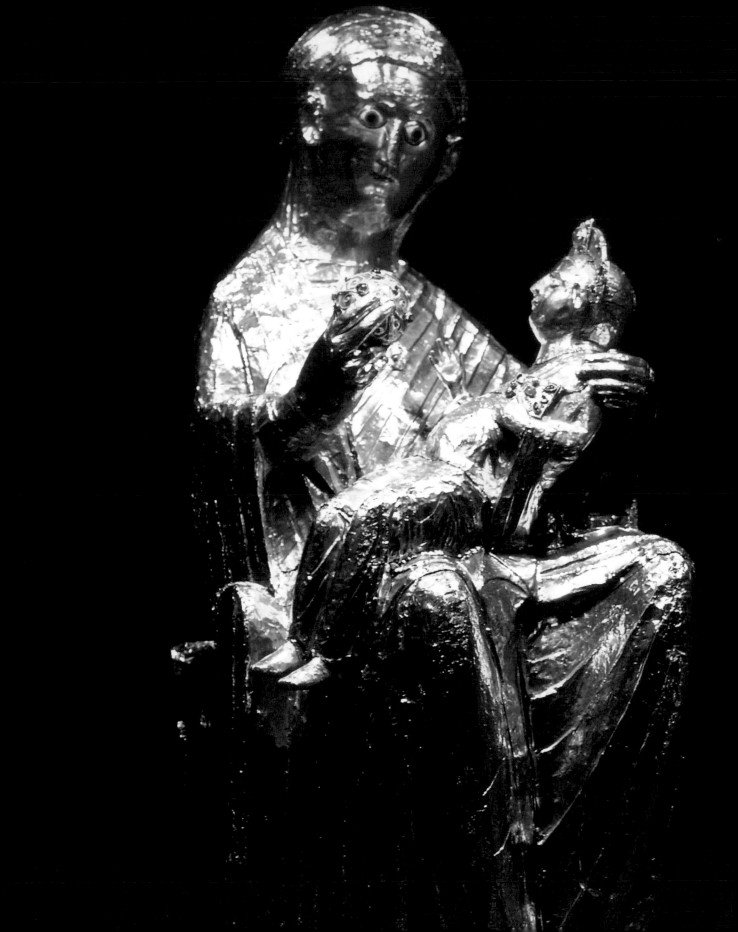

MARY, THE TRUE ARK OF THE COVENANT

In the Gospel we have just heard, Saint Luke, with various allusions, makes us understand that Mary is the true Ark of the Covenant, that the mystery of the temple—God's dwelling place here on earth—is fulfilled in Mary. God, who became present here on earth, truly dwells in Mary. Mary becomes his tent. What all the cultures desire—that God dwell among us—is brought about here.

Saint Augustine says: "Before conceiving the Lord in her body, she had already conceived him in her soul." She had made room for the Lord in her soul and thus really became the true Temple where God made himself incarnate, where he became present on this earth.

Thus, being God's dwelling place on earth, in her the eternal dwelling place has already been prepared, it has already been prepared for ever. And this constitutes the whole content of the Dogma of the Assumption of Mary, body and soul, into heavenly glory, expressed here in these words. Mary is "blessed" because—totally, in body and soul and for ever—she became the Lord's dwelling place. If this is true, Mary does not merely invite our admiration and veneration, but she guides us, shows us the way of life, shows us how we can become blessed, how to find the path of happiness. . . .

"All generations will call you blessed": this means that the future, what is to come, belongs to God, it is in God's hands, that it is God who conquers. Nor does he conquer the mighty dragon of which today's First Reading speaks, the dragon that represents all the powers of violence in the world. They seem invincible, but Mary tells us that they are not invincible.

The Woman—as the First Reading and the Gospel show us—is stronger, because God is stronger. Of course, in comparison with the dragon, so heavily armed, this Woman who is Mary, who is the Church, seems vulnerable or defenseless. And truly God is vulnerable in the world, because he is Love, and love is vulnerable. Yet he holds the future in his hands: it is love, not hatred, that triumphs; it is peace that is victorious in the end.

This is the great consolation contained in the Dogma of Mary's Assumption, body and soul, into heavenly glory. Let us thank the Lord for this consolation, but let us also see it as a commitment for us to take the side of good and peace. And let us pray to Mary, Queen of Peace, to help peace to be victorious today: "Queen of Peace, pray for us!"

Homily on the Assumption of Mary,
Castel Gandolfo, August 15, 2006

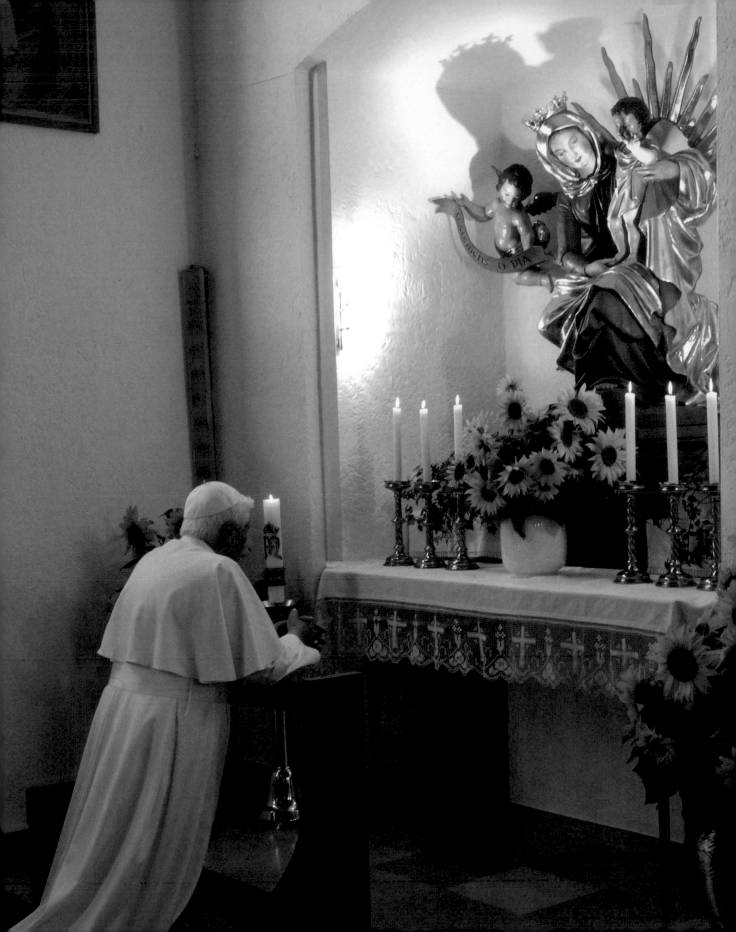

MARY, EXAMPLE AND SUPPORT
OF ALL BELIEVERS

The Christian tradition has placed, as we know, in the heart of summer a most ancient and evocative Marian feast, the Solemnity of the Assumption of the Blessed Virgin Mary. Like Jesus, risen from the dead and ascended to the right hand of the Father, so Mary, having finished the course of her earthly existence, was assumed into Heaven.

Today, the liturgy reminds us of this consoling truth of faith, while it sings the praises of her who has been crowned with incomparable glory. We read today in the verse from the Apocalypse proposed by the Church for our meditation: "And a great portent appeared in heaven, a woman clothed with the sun, with the moon under her feet, and on her head a crown of twelve stars" (12:1).

In this woman, resplendent with light, the Fathers of the Church have recognized Mary. In her triumph the Christian people, pilgrims in history, catch a glimpse of the fulfillment of its longing and a certain sign of its hope.

Mary is an example and support for all believers: she encourages us not to lose confidence before the difficulties and inevitable problems of every day. She assures us of her help and reminds us that it is essential to seek and think of "the things above, not those of the earth" (cf. Col 3:2).

Caught up in daily activities, we risk, in fact, to think that here, in this world through which we are only passing, is the ultimate goal of human existence. Instead, Paradise is the true goal of our earthly pilgrimage. How different our days would be if they were animated by this perspective! It was this way for the saints. Their lives witnessed to what they lived, with their hearts continually directed to God. Earthly realities are lived properly because the eternal truth of divine love illuminates them.

Angelus on the Assumption of Mary,
Castel Gandolfo, August 15, 2006

Pope Benedict XVI in the cemetery church of Pentling near Regensburg, where his parents and his sister are buried

81

YOUR POWER IS SERVICE

*H*oly Mother of the Lord! Our ancestors, at a time of trouble, set up your statue here, in the very heart of Munich, and entrusted the city and country to your care. They wanted to meet you again and again along the paths of their daily life and to learn from you the right way to live, to find God and to live in harmony. They gave you a crown and a scepter, which at that time were symbols of dominion over the country, because they knew that power and dominion would then be in good hands—in the hands of a Mother.

Your Son, just before his farewell to his disciples, said to them: "Whoever wishes to become great among you must be your servant, and whoever wishes to be first among you must be slave of all" (Mk 10:43–44). At the decisive hour in your own life, you said: "Here I am, the servant of the Lord" (Lk 1:38). You lived your whole life as service. And you continue to do so throughout history. At Cana, you silently and discreetly interceded for the spouses, and so you continue to do. You take upon yourself people's needs and concerns, and you bring them before the Lord, before your Son. Your power is goodness. Your power is service.

Teach us—great and small alike—to carry out our responsibilities in the same way. Help us to find the strength to offer reconciliation and forgiveness. Help us to become patient and humble, but also free and courageous, just as you were at the hour of the Cross. In your arms you hold Jesus, the Child who blesses, the Child who is also the Lord of the world. By holding the Child who blesses, you have yourself become a blessing. Bless us, this city and this country! Show us Jesus, the blessed fruit of your womb! Pray for us sinners, now and at the hour of our death. Amen!

Prayer before the Marian column in Munich, September 7, 2006

Foregoing double-page spread: Pope Benedict XVI before the Marian column in Munich, September 9, 2006

Right: Patroness of Bavaria on the Munich Marian column

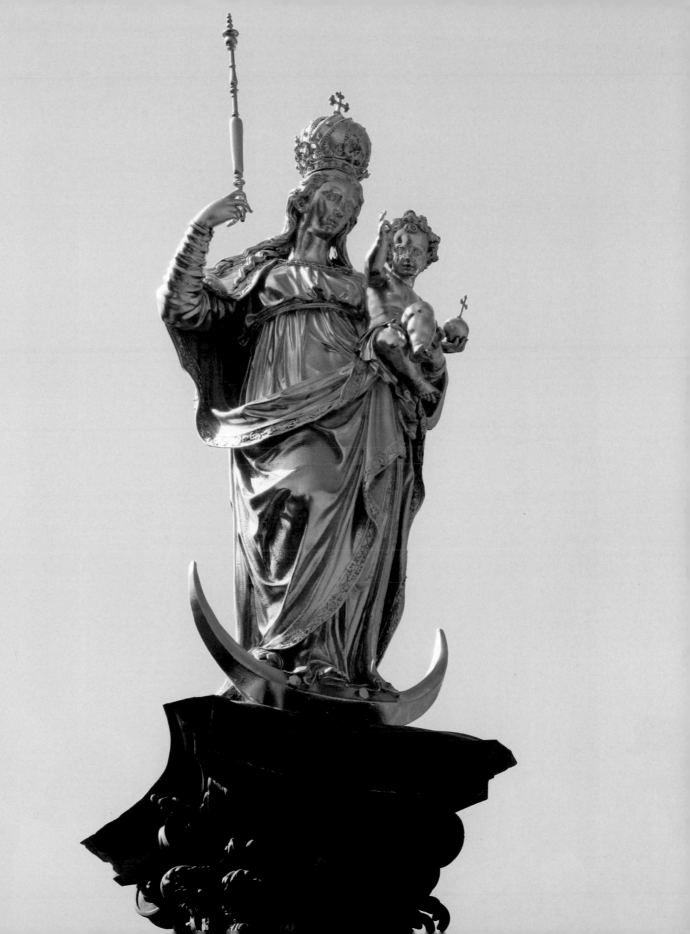

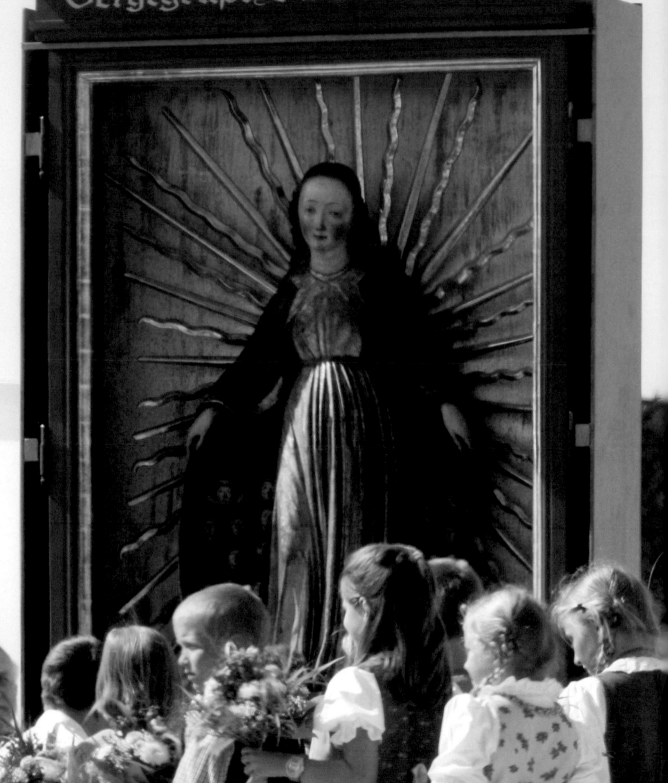

THOSE WHO BELIEVE ARE NEVER ALONE

Today we celebrate the feast of the "Most Holy Name of Mary". To all those women who bear that name—my own mother and my sister were among them, as the Bishop mentioned—I offer my heartfelt good wishes for their feast day. Mary, the Mother of the Lord, has received from the faithful the title of *Advocate*: she is our advocate before God. And this is how we see her, from the wedding feast of Cana onwards: as a woman who is kindly, filled with maternal concern and love, a woman who is attentive to the needs of others and, out of the desire to help them, brings those needs before the Lord. In today's Gospel we have heard how the Lord gave Mary as a Mother to the beloved disciple and, in him, to all of us. In every age, Christians have received with gratitude this legacy of Jesus, and, in their recourse to his Mother, they have always found the security and confident hope which gives them joy in God and makes us joyful in our faith in him. May we too receive Mary as the lodestar guiding our lives, introducing us into the great family of God! Truly, those who believe are never alone.

Homily in Regensburg, September 12, 2006

Foregoing double-page spread and right: Schutzmantel Madonna from the Dominican Church in Regensburg at the papal Mass on Islinger Field in Regensburg

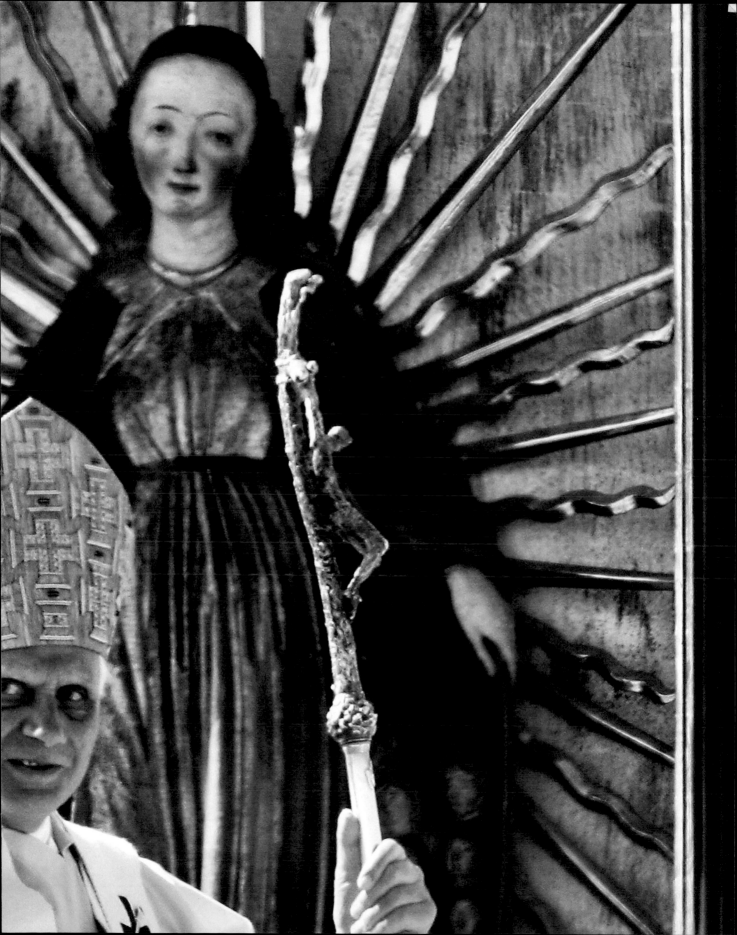

MARY UNDER THE CROSS

Mary was standing by the Cross (cf. Jn 19:25–27). Her sorrow is united with that of her Son. It is a sorrow full of faith and love. The Virgin on Calvary participates in the saving power of the suffering of Christ, joining her "*fiat*", her "yes", to that of her Son.

Dear brothers and sisters, spiritually united to Our Lady of Sorrows, let us also renew our "yes" to God, who chose the Way of the Cross in order to save us. This is a great mystery which continues and will continue to take place until the end of the world and which also asks for our collaboration.

May Mary help us to take up our cross every day and follow Jesus faithfully on the path of obedience, sacrifice and love.

Angelus after the Feast of the Exaltation of the Cross and the Memorial of Our Lady of Sorrows, September 17, 2006

Miraculous statue of Maria Vesperbild, Bavarian Swabia

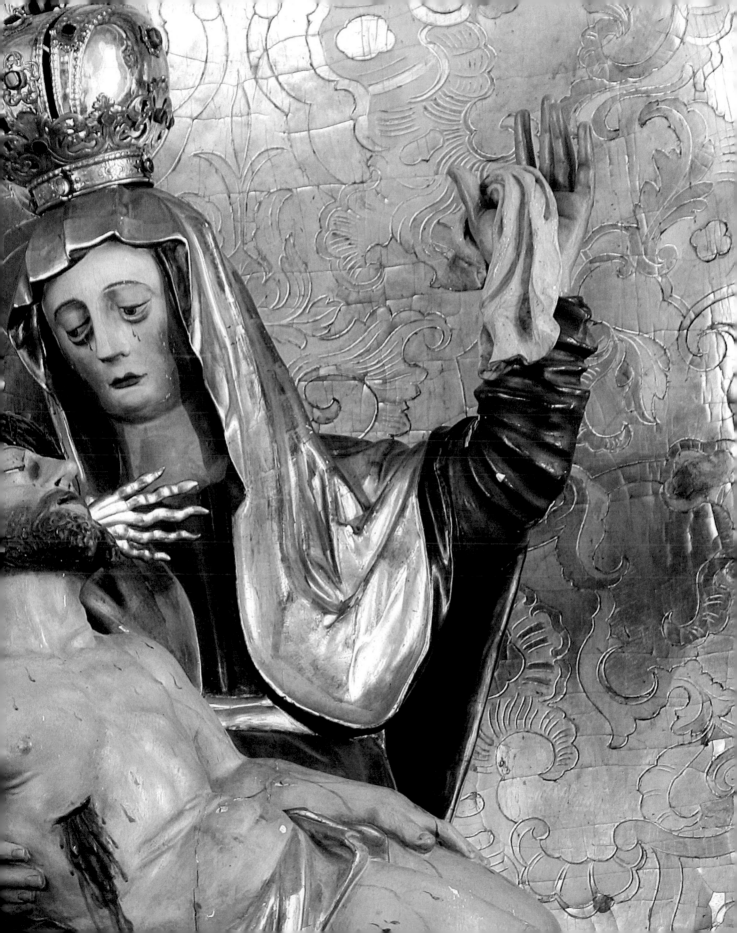

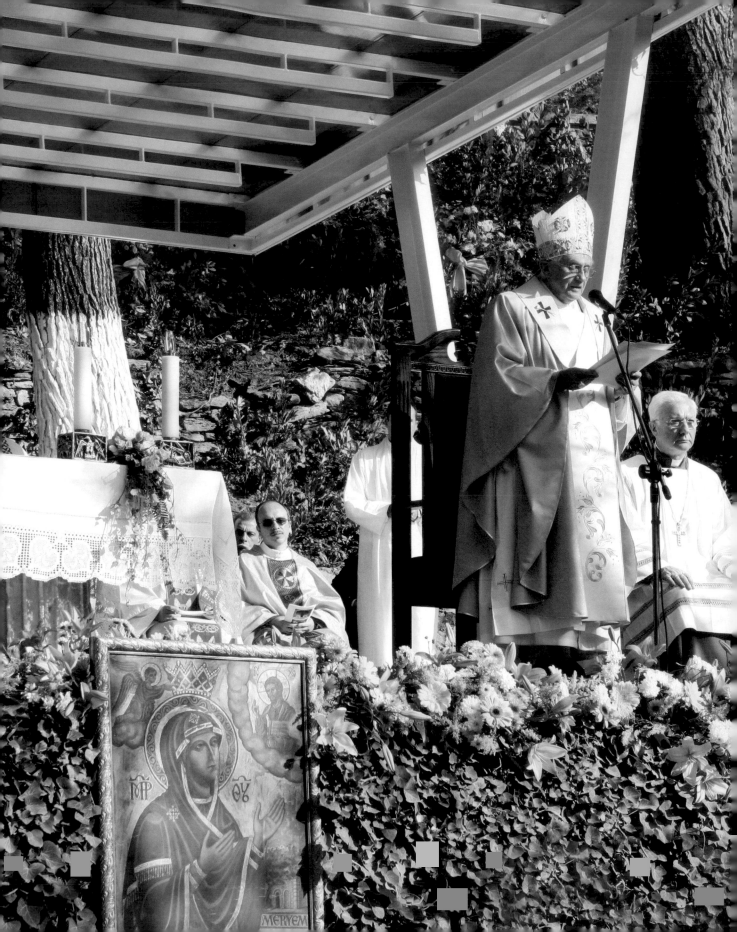

MOTHER OF GOD—MOTHER OF THE CHURCH

Mary's motherhood, which began with her "*fiat*" in Nazareth, is fulfilled at the foot of the Cross. Although it is true—as Saint Anselm says—that "from the moment of her *fiat* Mary began to carry all of us in her womb", the maternal vocation and mission of the Virgin towards those who believe in Christ actually began when Jesus said to her: "Woman, behold your son!" (Jn 19:26). Looking down from the Cross at his Mother and the beloved disciple by her side, the dying Christ recognized the firstfruits of the family which he had come to form in the world, the beginning of the Church and the new humanity. For this reason, he addressed Mary as "Woman", not as "Mother", the term which he was to use in entrusting her to his disciple: "Behold your Mother!" (Jn 19:27). The Son of God thus fulfilled his mission: born of the Virgin in order to share our human condition in everything but sin, at his return to the Father he left behind in the world the sacrament of the unity of the human race (cf. *Lumen Gentium*, no. 1): the family "brought into unity from the unity of the Father and the Son and the Holy Spirit" (Saint Cyprian, *De Orat. Dom.* 23: PL 4:536), at whose heart is this new bond between the Mother and the disciple. Mary's *divine motherhood* and her *ecclesial motherhood* are thus inseparably united.

Homily at the Marian shrine in Ephesus, Turkey, November 29, 2006

Picture at left and following double-page spread: Pope Benedict XVI before the Marian shrine of Meryem Ana Evì in Ephesus

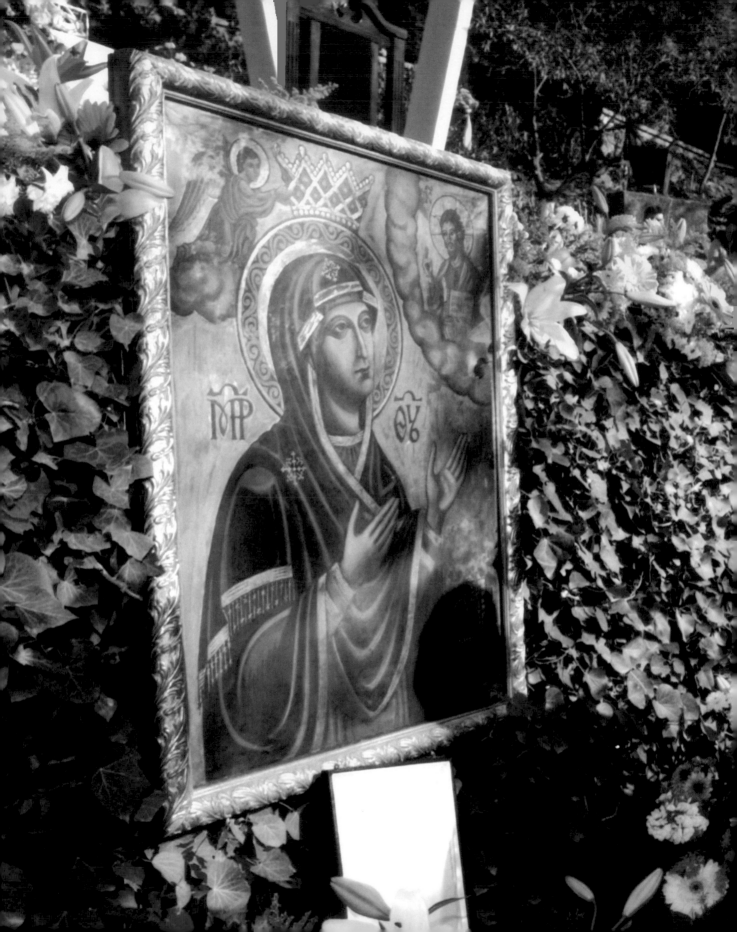

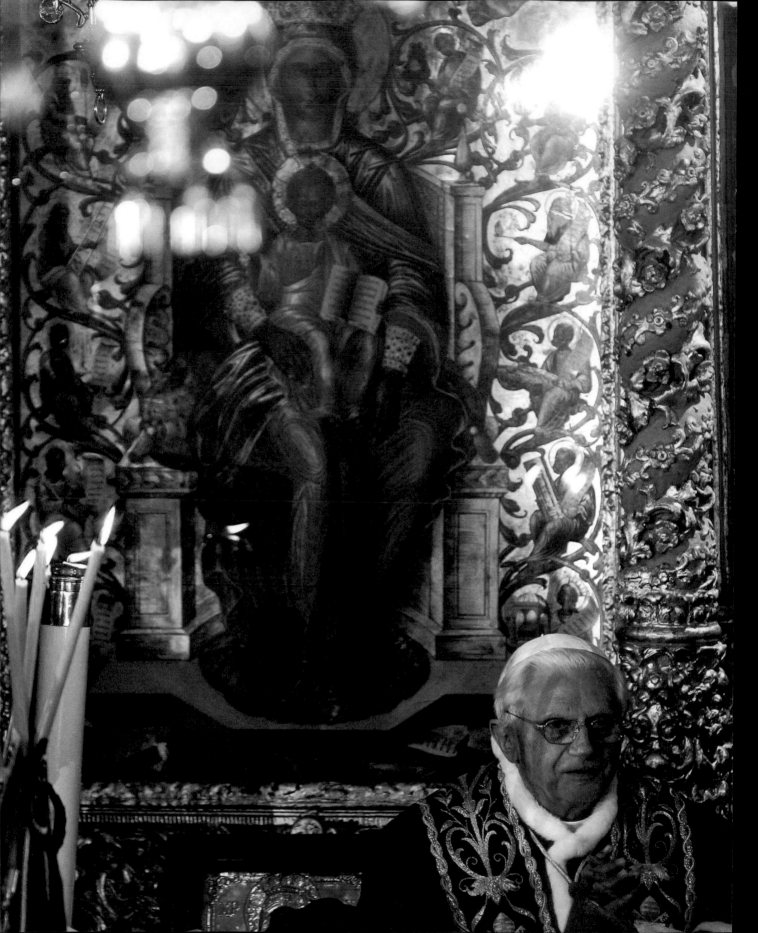

MOTHER OF THE REDEEMER

Today, we celebrate one of the most beautiful and popular feasts of the Blessed Virgin: the Immaculate Conception. Not only did Mary commit no sin, but she was also preserved from original sin, the common legacy of the human race. This is due to the mission for which God had destined her from eternity: to be the Mother of the Redeemer. All this is contained in the truth of faith of the "Immaculate Conception".

The biblical foundation of this Dogma is found in the words the Angel addressed to the young girl of Nazareth: "Hail, full of grace! The Lord is with you!" (Lk 1:28). "*Full of grace*" —in the original Greek, *kecharitoméne*—is Mary's most beautiful name, the name God himself gave to her to indicate that she has always been and will always be the *beloved*, the elect, the one chosen to welcome the most precious gift, Jesus: "the incarnate love of God" (*Deus Caritas Est*, no. 12). We might ask: why exactly did God choose from among all women Mary of Nazareth? The answer is hidden in the unfathomable mystery of the divine will.

There is one reason, however, which is highlighted in the Gospel: her humility. Dante Alighieri clearly emphasizes this in the last Hymn of Paradise: "Virgin Mother, daughter of your Son, lowly and exalted more than any creature, the fixed goal of eternal counsel . . ." (*Paradise*, XXXIII, 1–3). In the *Magnificat*, her canticle of praise, the Virgin herself says: "My soul

Pope Benedict XVI in the Patriarchal Church of Saint George, Istanbul, November 30, 2006

magnifies the Lord . . . because he looked upon his servant in her lowliness" (Lk 1:46, 48).

Yes, God was attracted by the humility of Mary, who found favor in his eyes (cf. Lk 1:30). She thus became the Mother of God, the image and model of the Church, chosen among the peoples to receive the Lord's blessing and communicate it to the entire human family.

This "blessing" is none other than Jesus Christ. He is the Source of the *grace* which filled Mary from the very first moment of her existence. She welcomed Jesus with faith and gave him to the world with love. This is also our vocation and our mission, the vocation and mission of the Church: to welcome Christ into our lives and give him to the world, so "that the world might be saved through him" (Jn 3:17).

Dear brothers and sisters, may today's Feast of the Immaculate Conception illuminate like a beacon the Advent Season, which is a time of vigilant and confident waiting for the Savior. While we advance towards God who comes, let us look at Mary, who "shines forth. . . , a sign of certain hope and comfort to the pilgrim People of God" (*Lumen Gentium*, no. 68).

With this awareness, I invite you to join me in Piazza di Spagna this afternoon, when I will renew the traditional act of homage to this sweet Mother *by* grace and *of* grace.

Angelus on the Solemnity of the Immaculate Conception, December 8, 2006

Pope Benedict XVI before the Marian column in the Piazza di Spagna, Rome, December 8, 2005

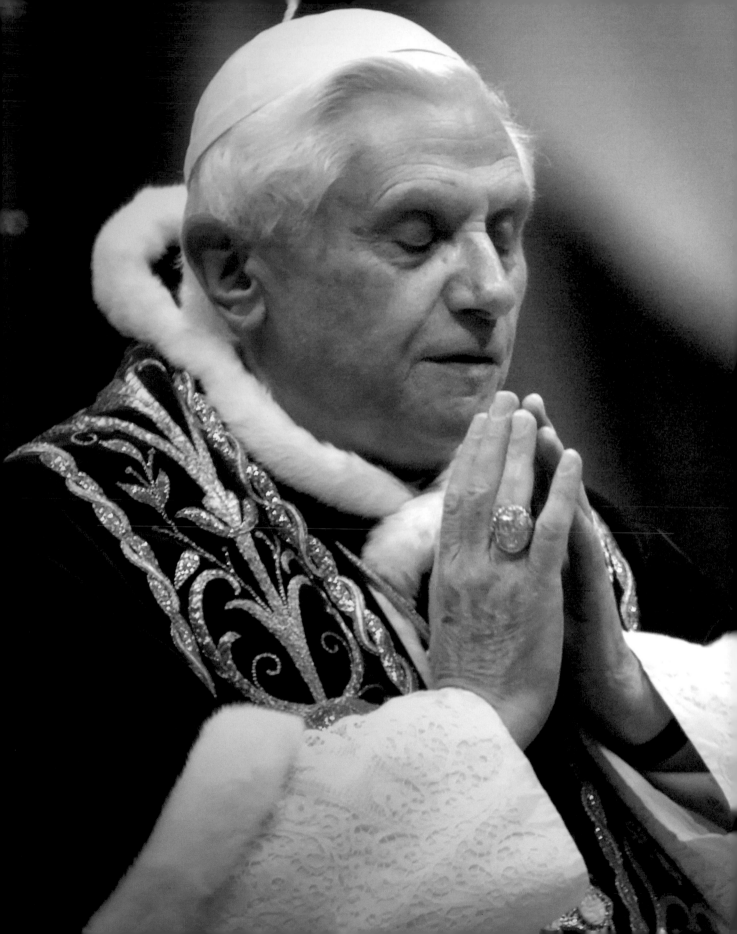

FULL OF GRACE

O Mary, Immaculate Virgin! Again this year, with filial love, we meet at the foot of your image to renew to you the homage of the Christian community and of the city of Rome. Let us pause in prayer here, following the tradition inaugurated by previous Popes, on the solemn day in which the liturgy celebrates your Immaculate Conception, a mystery that is a source of joy and hope for all the redeemed. We greet you and call upon you with the Angel's words: "full of grace" (Lk 1:28), the most beautiful name that God himself has called you from eternity.

"Full of grace" are you, Mary, full of divine love from the very first moment of your existence, providentially predestined to be Mother of the Redeemer and intimately connected to him in the mystery of salvation. In your Immaculate Conception shines forth the vocation of Christ's disciples, called to become, with his grace, saints and immaculate through love (cf. Eph 1:4). In you shines the dignity of every human being, who is always precious in the Creator's eyes. Those who look to you, All Holy Mother, never lose their serenity, no matter what the hardships of life. Although the experience of sin is a sad one since it disfigures the dignity of God's children, anyone who turns to you discovers the beauty of truth and love and finds the path that leads to the Father's house.

"Full of grace" are you, Mary, who, welcoming the Creator's plan with your "yes", opened to us the path of salvation. Teach us also at your school to say our "yes" to the Lord's will. Let it be a "yes" that joins with your own "yes", without reservations or shadows, a "yes" that the Heavenly Father willed to have need of in order to beget the new Man, Christ, the one Savior of the world and of history.

Pope Benedict XVI in Saint Peter's Basilica, February 2, 2007

Give us the courage to say "no" to the deceptions of power, money, pleasure; to dishonest earnings, corruption and hypocrisy, to selfishness and violence; "no" to the Evil One, the deceitful prince of this world; to say "yes" to Christ, who destroys the power of evil with the omnipotence of love. We know that only hearts converted to Love, which is God, can build a better future for all.

"*Full of grace*" are you, Mary! For all generations your name is a pledge of sure hope. Yes! Because, as the great poet Dante wrote, for us mortals you are "a source of living hope" (*Paradise*, XXXIII, 12). Let us come once again as trusting pilgrims to draw faith and comfort, joy and love, safety and peace from this source, the wellspring of your Immaculate Heart.

Virgin "full of grace", show yourself to be a tender and caring Mother to those who live in this city of yours, so that the truc Gospel spirit may enliven and guide their conduct; show yourself as Mother and watchful keeper of Italy and Europe, so that people may draw from their ancient Christian roots fresh vigor to build their present and their future; show yourself as a provident and merciful Mother to the whole world so that, by respecting human dignity and rejecting every form of violence and exploitation, sound foundations may be laid for the civilization of love.

Show yourself as Mother, especially to those most in need: the defenseless, the marginalized and outcasts, to the victims of a society that all too often sacrifices the human person for other ends and interests.

Show yourself, O Mary, as Mother of all, and give us Christ, the Hope of the world! "*Monstra Te esse Matrem*", O Virgin Immaculate, full of grace! Amen!

Prayer before the Marian column in the Piazza di Spagna, Rome, December 8, 2006

Pope Benedict XVI at the Kalwaria Zebrzydowska Marian shrine, Poland, May 27, 2006

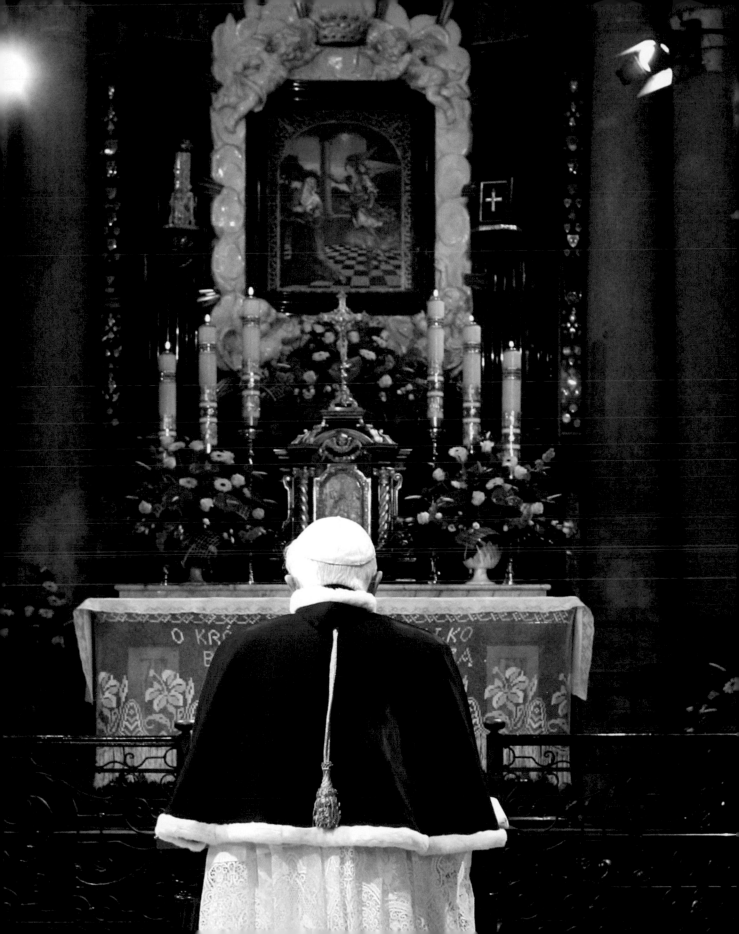

MARY, STAR OF EVANGELIZATION

At a crucial time in history, Mary offered herself, her body and soul, to God as a dwelling place. In her and from her the Son of God took flesh. Through her the Word was made flesh (cf. Jn 1:14). Thus, it is Mary who tells us what Advent is: going forth to meet the Lord who comes to meet us; waiting for him, listening to him, looking at him. Mary tells us why church buildings exist: they exist so that room may be made within us for the Word of God; so that within us and through us the Word may also be made flesh today.

Thus, we greet her as the Star of Evangelization: Holy Mary, Mother of God, pray for us so that we may live the Gospel. Help us not to hide the light of the Gospel under the bushel of our meager faith. Help us by virtue of the Gospel to be the light of the world, so that men may see goodness and glorify the Father who is in Heaven (cf. Mt 5:14ff.).

Homily, December 10, 2006

Pope Benedict XVI with Marian Mass vestments at the celebration of the Eucharist with new cardinals, November 25, 2007

Following double-page spread: Our Lady of Aparecida, Brazil

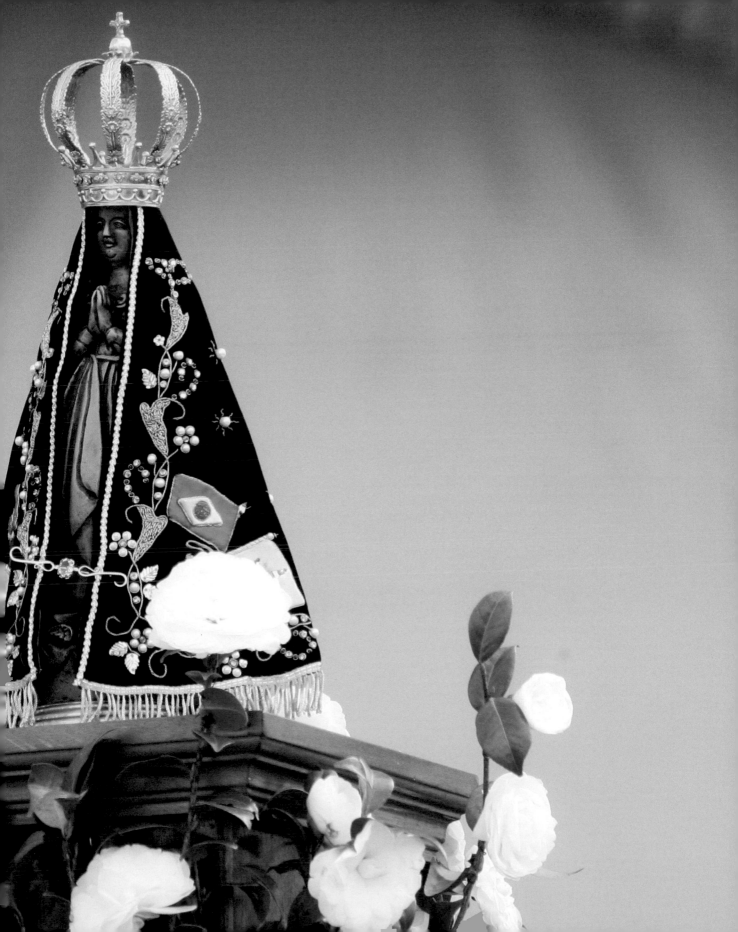

REMAIN IN THE SCHOOL OF MARY

We have just prayed the Rosary. Through these sequences of meditations, the divine Comforter seeks to initiate us in the knowledge of Christ that issues forth from the clear source of the Gospel text. For her part, the Church of the third millennium proposes to offer Christians the capacity for "knowledge of God's mystery, of Christ, in whom are hid all the treasures of wisdom and knowledge" (Col 2:2–3), according to the words of Saint Paul. Mary Most Holy, the pure and immaculate Virgin, is for us a school of faith destined to guide us and give us strength on the path that leads us to the Creator of Heaven and earth. The Pope has come to Aparecida with great joy so as to say to you first of all: "Remain in the school of Mary." Take inspiration from her teachings, seek to welcome and to preserve in your hearts the enlightenment that she, by divine mandate, sends you from on high. How beautiful it is to be gathered here in the name of Christ, in faith, in fraternity, in joy, in peace and in prayer, together with "Mary, the mother of Jesus" (Acts 1:14). . . .

Let us ask the Mother of God, Our Lady of Aparecida, to protect the lives of all Christians. May she, who is the Star of Evangelization, guide our steps along the path towards the heavenly Kingdom:

"Our Mother, protect the Brazilian and Latin American family!

Guard under your protective mantle the children of this beloved land that welcomes us,

As the Advocate with your Son Jesus, give to the Brazilian people constant peace and full prosperity,

Pour out upon our brothers and sisters throughout Latin America a true missionary ardor, to spread faith and hope,

Make the resounding plea that you uttered in Fatima for the conversion of sinners become a reality that transforms the life of our society,

And as you intercede, from the Shrine of Guadalupe, for the people of the Continent of Hope, bless its lands and its homes,

Amen."

Address at the Rosary in Aparecida, Brazil, May 12, 2007

Picture at right and following double-page spread: Pope Benedict XVI at the Rosary with students, March 12, 2007

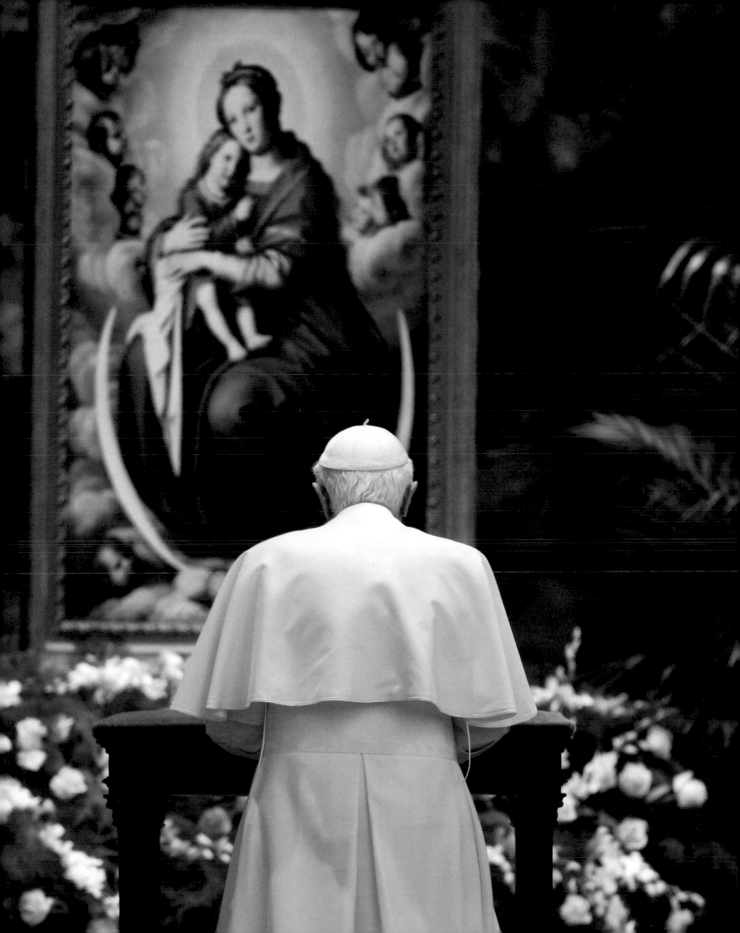

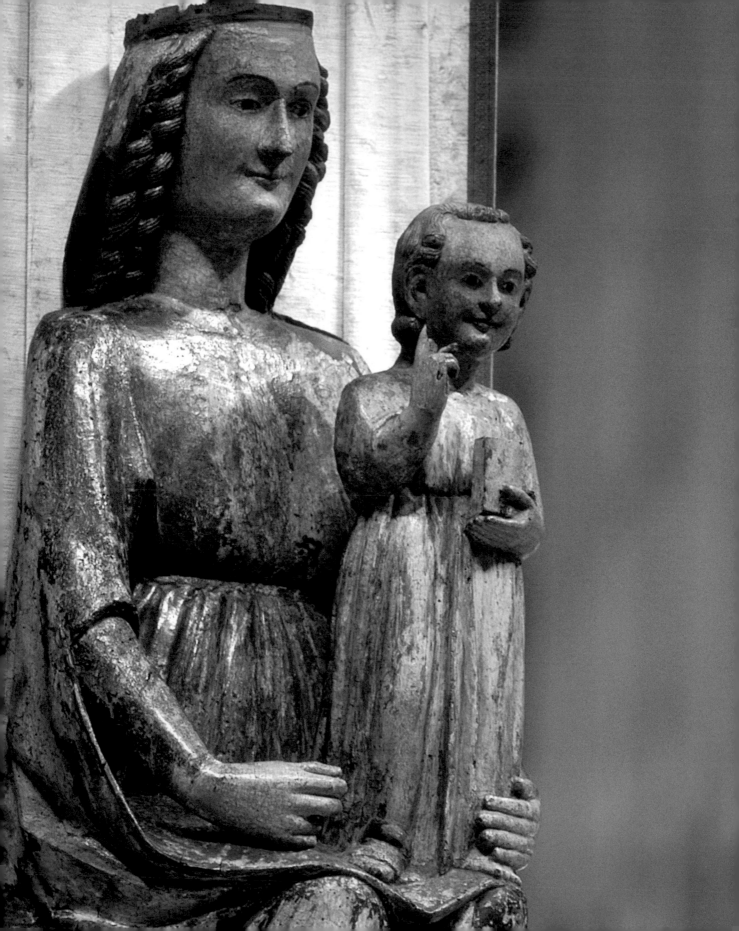

VIRGIN AND MOTHER

Mary is Mother, but a Virgin Mother; Mary is a virgin, but a Mother Virgin. If either of these aspects is ignored, the mystery of Mary as the Gospels present her to us cannot be properly understood. As Mother of Christ, Mary is also *Mother of the Church*.... Lastly, Mary is the *Spiritual Mother of all mankind*, because Jesus on the Cross shed his blood for all of us, and from the Cross he entrusted us all to her maternal care.

Homily on the Solemnity of Mary, Mother of God, January 1, 2007

The Christian community, which in these days has remained in prayerful adoration before the crib, looks with particular love to the Virgin Mary, identifying itself with her while contemplating the newborn Baby, wrapped in swaddling clothes and laid in a manger. Like Mary, the Church also remains in silence in order to welcome and keep the interior resonances of the Word made flesh and in order not to lose the divine-human warmth that radiates from his presence. The Church, like the Virgin, does none other than show Jesus, the Savior, to everyone and reflects to each one the light of his face, the splendor of goodness and truth.

Angelus, January 1, 2007

Picture at left and on the following double-page spread: Vespers in honor of the Mother of God, Saint Peter's Basilica, December 31, 2005

ANNUNCIATION TO MARY

The Annunciation, recounted at the beginning of Saint Luke's Gospel, is a humble, hidden event—no one saw it, no one except Mary knew of it—but at the same time it was crucial to the history of mankind. When the Virgin said her "yes" to the Angel's announcement, Jesus was conceived, and with him began the new era of history that was to be ratified in Easter as the "new and eternal Covenant".

In fact, Mary's "yes" perfectly mirrors that of Christ himself when he entered the world, as the Letter to the Hebrews says, interpreting Psalm 40[39]: "As is written of me in the book, I have come to do your will, O God" (Heb 10:7). The Son's obedience was reflected in that of the Mother, and thus, through the encounter of these two "yeses", God was able to take on a human face. This is why the Annunciation is a Christological feast as well, because it celebrates a central mystery of Christ: the Incarnation.

"Behold, I am the handmaid of the Lord, let it be done to me according to your Word." Mary's reply to the Angel is extended in the Church, which is called to make Christ present in history, offering her own availability so that God may continue to visit mankind with his mercy.

Angelus on the Annunciation to Mary,
March 25, 2007

Pope Benedict XVI visits the church of
Santa Orsola in Vigo di Cadore, Northern Italy,
July 25, 2007

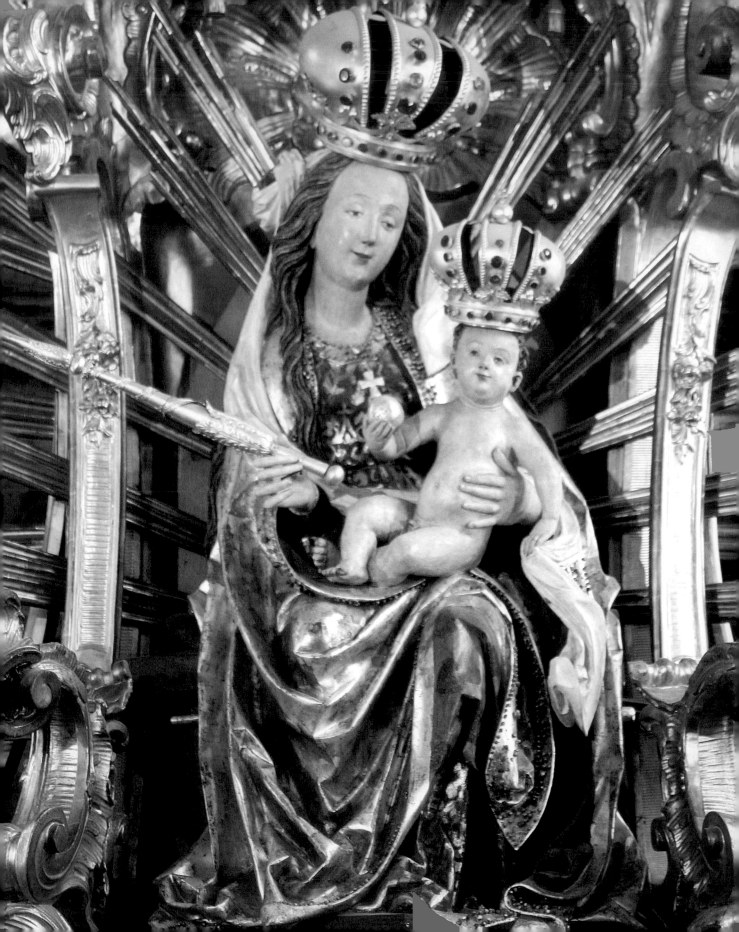

MARY, QUEEN

Today, we are celebrating the Solemnity of the Assumption of the Blessed Virgin Mary. This is an ancient feast deeply rooted in Sacred Scripture: indeed, it presents the Virgin Mary closely united to her divine Son and ever supportive of him.

Mother and Son appear closely bound in the fight against the infernal enemy until they completely defeat him. This victory is expressed in particular in overcoming sin and death, that is, in triumphing over the enemies which Saint Paul always presents as connected (cf. Rom 5:12, 15–21; 1 Cor 15:21–26).

Therefore, just as Christ's glorious Resurrection was the definitive sign of this victory, so Mary's glorification in her virginal body is the ultimate confirmation of her total solidarity with the Son, both in the conflict and in victory.

The Servant of God Pope Pius XII interpreted the deep theological meaning of this mystery on 1 November 1950 when he pronounced the solemn Dogmatic Definition of this Marian privilege.

He declared: "Hence, the revered Mother of God, from all eternity joined in a hidden way with Jesus Christ in one and the same decree of predestination, immaculate in her conception, a most perfect virgin in her divine motherhood, the noble associate of the divine Redeemer who has won a complete triumph over sin and its consequences, finally obtained, as the supreme culmination of her privileges, that she should be preserved free from the corruption of the tomb and that, like her own Son, having overcome death, she might be taken up body and soul to the glory of Heaven, where, as Queen, she sits in splendor at the right hand of her Son, the immortal King of the Ages" (Apostolic Constitution *Munificentissimus Deus*: AAS 42 [1 November 1950]).

Dear brothers and sisters, after being taken up into Heaven, Mary did not distance herself from us but continues to be even closer to us, and her light shines on our lives and on the history of all mankind. Attracted by the heavenly brightness of the Mother of the Redeemer, let us turn with trust to the One who looks upon us and protects us from on high.

We all need her help and comfort to face the trials and challenges of daily life; we need to feel that she is our Mother and sister in the concrete situations of our lives. And so that we too may one day be able to share in her same destiny, let us imitate her now in her meek following of Christ and her generous service to the brethren. This is the only way to have a foretaste, already on our earthly pilgrimage, of the joy and peace which those who reach the immortal destination of Paradise live to the full. . . .

Angelus on Mary's Assumption, Castel Gandolfo, August 15, 2007

Crowned Madonna in the Fatima Grotto of Maria Vesperbild, Bavarian Swabia

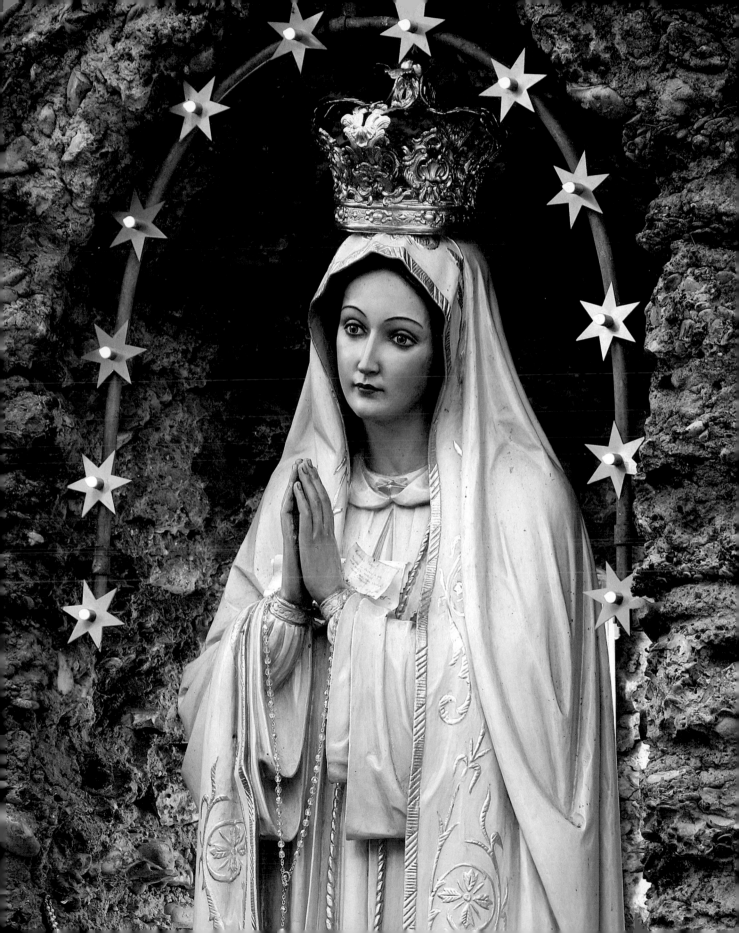

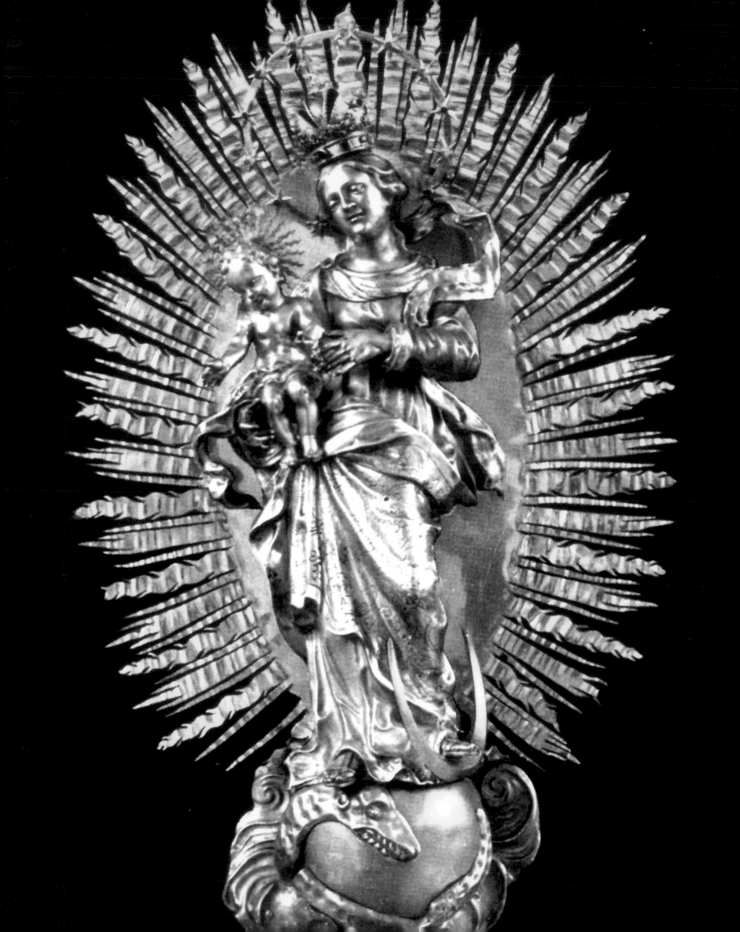

WOMAN CLOTHED WITH THE SUN

Mary, who lives totally in God, surrounded and penetrated by God's light. Surrounded by the twelve stars, that is, by the twelve tribes of Israel, by the whole People of God, by the whole Communion of Saints; and at her feet, the moon, the image of death and mortality. Mary has left death behind her; she is totally clothed in life, she is taken up body and soul into God's glory, and thus, placed in glory after overcoming death, she says to us: Take heart, it is love that wins in the end! The message of my life was: I am the handmaid of God, my life has been a gift of myself to God and my neighbor. And this life of service now arrives in real life. May you too have trust and have the courage to live like this, countering all the threats of the dragon.

This is the first meaning of the woman whom Mary succeeded in being. The "woman clothed with the sun" is the great sign of the victory of love, of the victory of goodness, of the victory of God; a great sign of consolation. Yet, this woman who suffered, who had to flee, who gave birth with cries of anguish, is also the Church, the pilgrim Church of all times. In all generations she has to give birth to Christ anew, to bring him very painfully into the world, with great suffering. Persecuted in all ages, it is almost as if, pursued by the dragon, she had gone to live in the wilderness.

However, in all ages, the Church, the People of God, also lives by the light of God and, as the Gospel says, is nourished by God, nourishing herself with the Bread of the Holy

Madonna in Strahlenkranz,
Basilica of Saint Vitus, Ellwangen

Eucharist. Thus, in all the trials in the various situations of the Church through the ages in different parts of the world, she wins through suffering. And she is the presence, the guarantee of God's love against all the ideologies of hatred and selfishness.

We see of course that today too the dragon wants to devour God who made himself a Child. Do not fear for this seemingly frail God; the fight has already been won. Today too, this weak God is strong: he is true strength.

Thus, the Feast of the Assumption is an invitation to trust in God and also to imitate Mary in what she herself said: Behold, I am the handmaid of the Lord; I put myself at the Lord's disposal.

This is the lesson: one should travel on one's own road; one should give life and not take it. And precisely in this way each one is on the journey of love which is the loss of self, but this losing of oneself is in fact the only way truly to find oneself, to find true life.

Let us look to Mary, taken up into Heaven. Let us be encouraged to celebrate the joyful feast with faith: God wins. Faith, which seems weak, is the true force of the world. Love is stronger than hate. And let us say with Elizabeth: Blessed are you among women. Let us pray to you with all the Church: Holy Mary, Mother of God, pray for us sinners, now and at the hour of our death. Amen.

Homily on the Assumption of Mary, Castel Gandolfo, August 15, 2007

Pope Benedict XVI, before the miraculous Mother of Mariazell, September 8, 2007

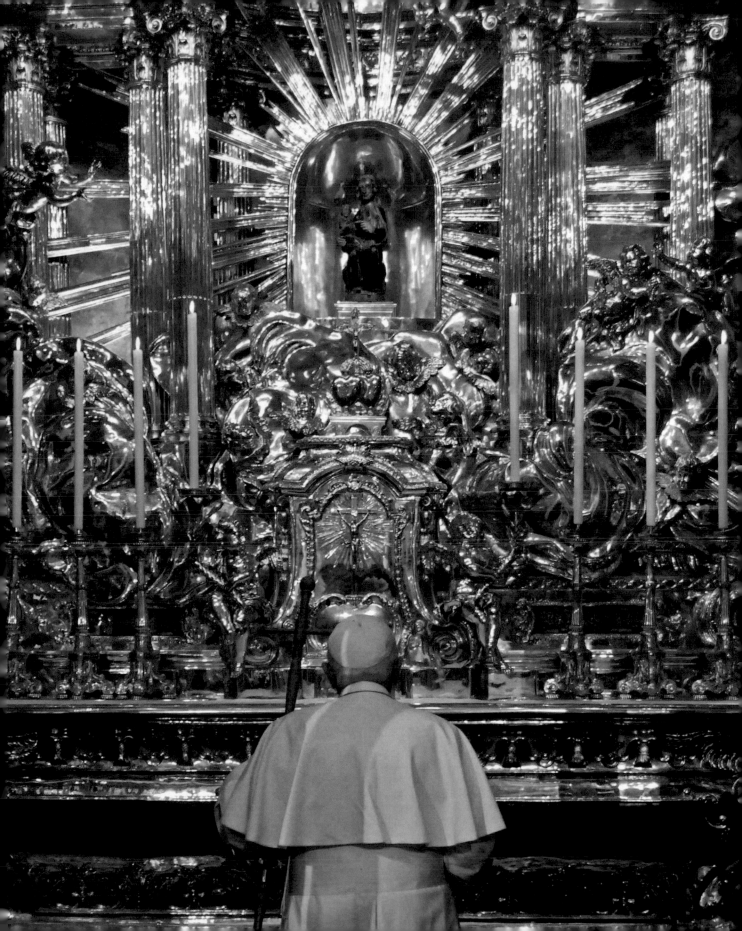

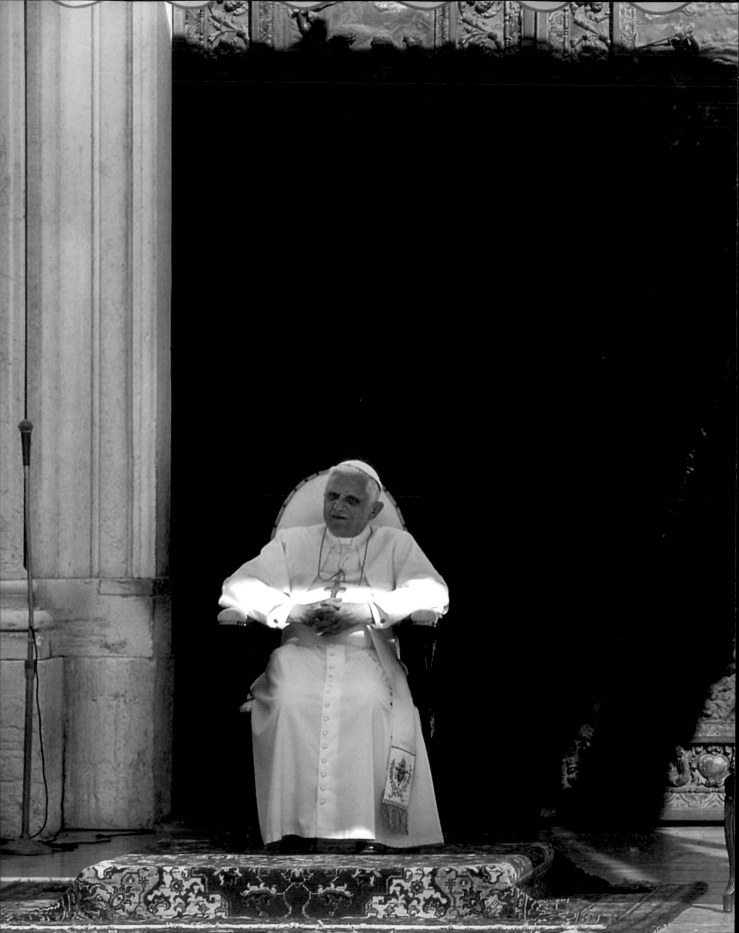

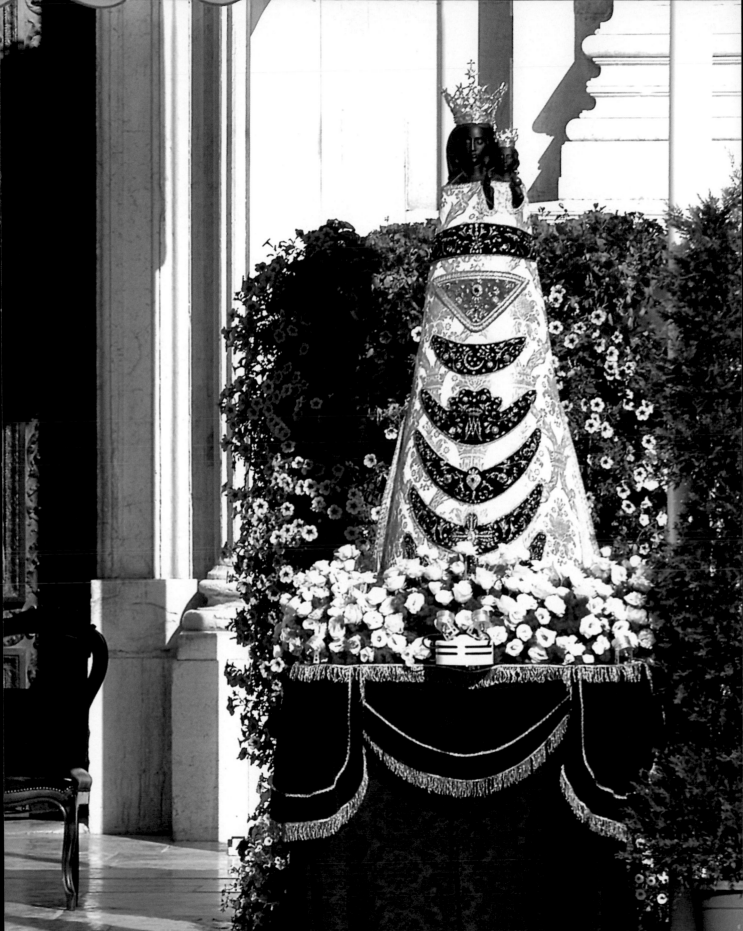

MARY, GATE OF HEAVEN

Mary, Mother of the "Yes", you listened to Jesus
and know the tone of his voice and the beating of his heart.
Morning Star, speak to us of him,
and tell us about your journey of following him on the path of faith.

Mary, who dwelt with Jesus in Nazareth,
impress on our lives your sentiments,
your docility, your attentive silence,
and make the Word flourish in genuinely free choices.

Mary, speak to us of Jesus, so that the freshness of our faith
shines in our eyes and warms the heart of those we meet,
as you did when visiting Elizabeth,
who in her old age rejoiced with you for the gift of life.

Mary, Virgin of the *Magnificat*
help us to bring joy to the world, and, as at Cana,
lead every young person involved in service of others
to do only what Jesus will tell them.

Mary, look upon the *Agora* of youth,
so that the soil of the Italian Church will be fertile.
Pray that Jesus, dead and Risen, is reborn in us
and transforms us into a night full of light, full of him.

Mary, Our Lady of Loreto, Gate of Heaven,
help us to lift our eyes on high.
We want to see Jesus, to speak with him,
to proclaim his love to all.

Prayer at the Marian Shrine of Loreto,
September 1, 2007

Foregoing double-page spread and picture at right:
Pope Benedict XVI in Loreto, September 1, 2007

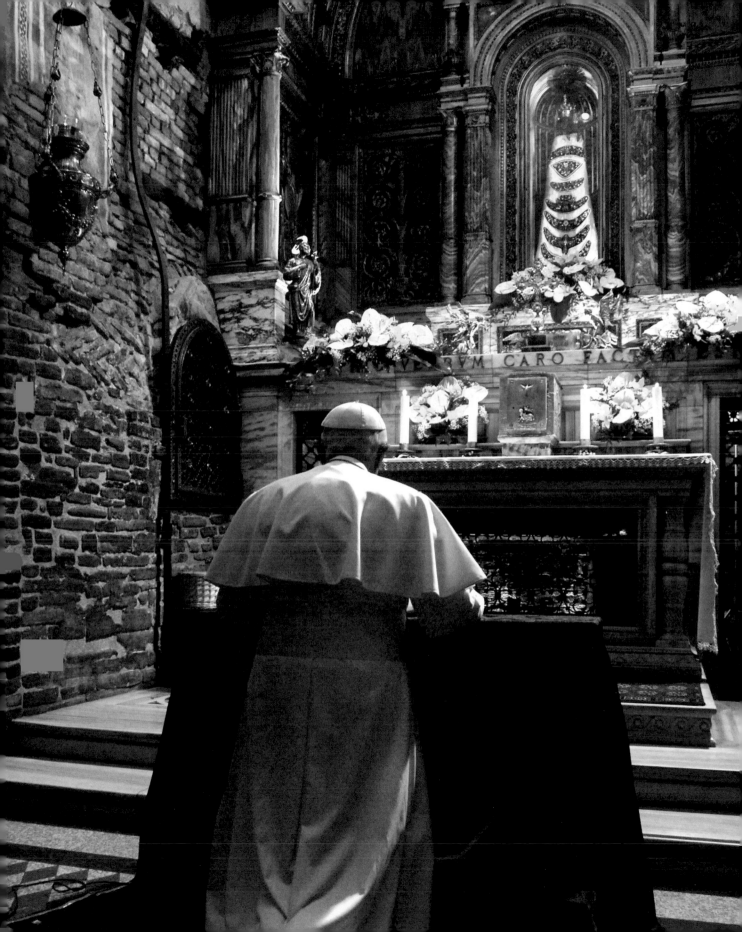

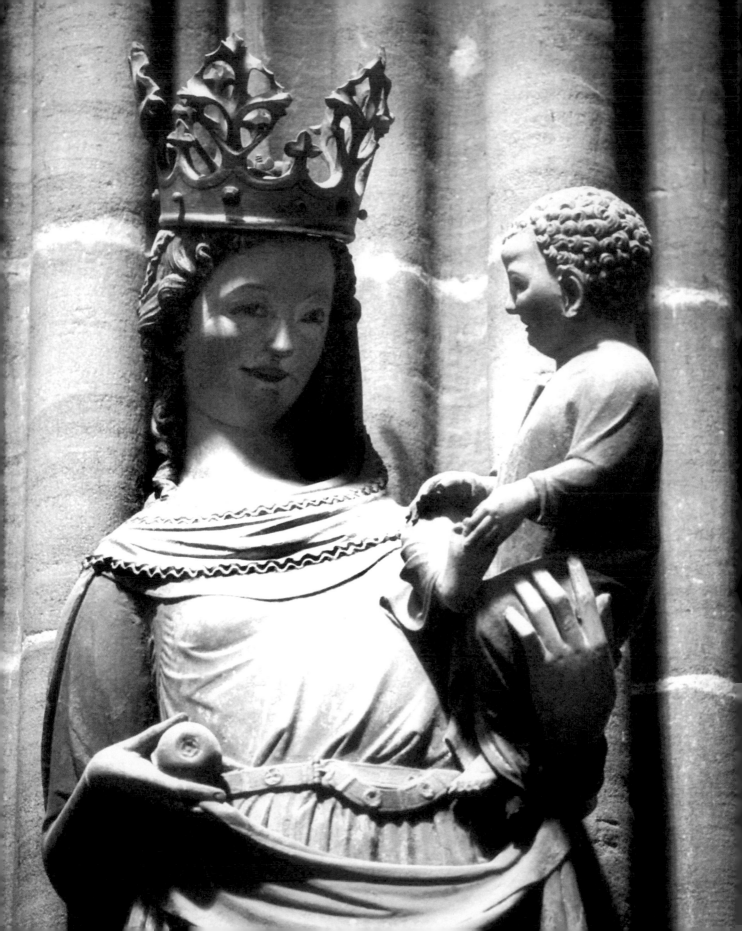

HOLY MARY, IMMACULATE MOTHER

How many persons, over the years, have stood before this column and lifted their gaze to Mary in prayer! How many have experienced in times of trouble the power of her intercession! Our Christian hope includes much more than the mere fulfillment of our wishes and desires, great or small. We turn our gaze to Mary, because she points out to us the great hope to which we have been called (cf. Eph 1:18), because she personifies our true humanity!

This is what we have just heard in the biblical reading: even before the creation of the world, God chose us in Christ. From eternity he has known and loved each one of us! And why did he choose us? To be holy and immaculate before him in love! This is no impossible task: in Christ he has already brought it to fulfillment. We have been redeemed! By virtue of our communion with the Risen Christ, God has blessed us with every spiritual blessing. Let us open our hearts; let us accept this precious legacy! Then we will be able to sing, together with Mary, the praises of his glorious grace. And if we continue to bring our everyday concerns to the immaculate Mother of Christ, she will help us to open our little hopes ever more fully towards that great and true hope which gives meaning to our lives and is able to fill us with a deep and imperishable joy.

With these sentiments I would now like to join you in looking to Mary Immaculate, entrusting to her intercession the prayers which you have just now presented and imploring her maternal protection upon this country and its people:

Holy Mary, Immaculate Mother of our Lord Jesus Christ, in you God has given us the model of the Church and of genuine humanity. To you I entrust the country of Austria and its people. Help all of us to follow your example and to direct our lives completely to God! Grant that, by looking to Christ, we may become ever more like him: true children of God! Then we too, filled with every spiritual blessing, will be able to conform ourselves more fully to his will and to become instruments of his peace for Austria, Europe and the world. Amen.

Prayer before the Marian column in Vienna, September 7, 2007

Madonna in Saint Stephen's Cathedral, Vienna

MARY, QUEEN OF THE ROSARY

The traditional image of Our Lady of the Rosary portrays Mary with one arm supporting the Child Jesus and with the other offering the rosary beads to Saint Dominic. This important iconography shows that the Rosary is a means given by the Virgin to contemplate Jesus and, in meditating on his life, to love him and follow him ever more faithfully. It is this message that Our Lady has also bequeathed to us in her various apparitions. I am thinking in particular of the apparition in Fatima that occurred ninety years ago. Presenting herself as "Our Lady of the Rosary", she insistently recommended the daily recitation of the Rosary to the three little shepherd children, Lucia, Jacinta and Francisco, in order to obtain the end of the war. Let us also accept the Virgin's motherly request, pledging to recite the Rosary with faith for peace in families, nations and throughout the world. . . .

In the month of October, we venerate Mary in a special way as the Queen of the Holy Rosary. In praying the Rosary, we look with Mary at Christ. The Mother shows us her Son and wants for us, too, to be always very close to him and to live in communion with him. We trust in the power of prayer, and we beg Mary, our heavenly Mother, for her intercession. May the Lord grant you all his grace.

Angelus, October 7, 2007

Our Lady of Lourdes with the Rosary, Saint Peter's Basilica

Following double-page spread: Feast of Our Lady of Lourdes, February 11, 2007

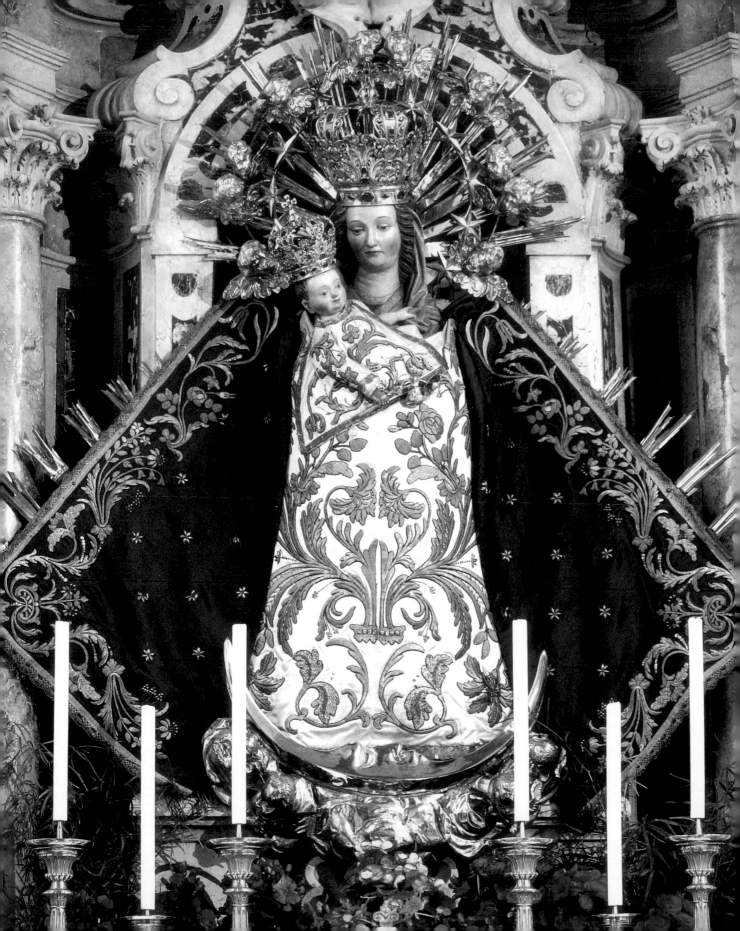

MARY, STAR OF HOPE

With a hymn composed in the eighth or ninth century, thus for over a thousand years, the Church has greeted Mary, the Mother of God, as "Star of the Sea": *Ave maris stella.* Human life is a journey. Towards what destination? How do we find the way? Life is like a voyage on the sea of history, often dark and stormy, a voyage in which we watch for the stars that indicate the route. The true stars of our life are the people who have lived good lives. They are lights of hope. Certainly, Jesus Christ is the true light, the sun that has risen above all the shadows of history. But to reach him we also need lights close by—people who shine with his light and so guide us along our way. Who more than Mary could be a star of hope for us? With her "yes" she opened the door of our world to God himself; she became the living Ark of the Covenant, in whom God took flesh, became one of us and pitched his tent among us (cf. Jn 1:14).

So we cry to her: Holy Mary, you belonged to the humble and great souls of Israel who, like Simeon, were "looking for the consolation of Israel" (Lk 2:25) and hoping, like Anna, "for the redemption of Jerusalem" (Lk 2:38). Your life was thoroughly imbued with the sacred scriptures of Israel, which spoke of hope, of the promise made to Abraham and his descendants (cf. Lk 1:55). In this way we can appreciate the holy fear that overcame you when the Angel of the Lord appeared to you and told you that you would give birth to the One who was the hope of Israel, the One awaited by the world. Through you, through your "yes", the hope of the ages became reality, entering this world and its history. You bowed low before the greatness of this task and gave your

Miraculous statue of Maria Trens, Alto Adige

137

consent: "Behold, I am the handmaid of the Lord; let it be to me according to your word" (Lk 1:38). When you hastened with holy joy across the mountains of Judea to see your cousin Elizabeth, you became the image of the Church to come, which carries the hope of the world in her womb across the mountains of history. But alongside the joy which, with your *Magnificat*, you proclaimed in word and song for all the centuries to hear, you also knew the dark sayings of the prophets about the suffering of the servant of God in this world. Shining over his birth in the stable at Bethlehem, there were Angels in splendor who brought the good news to the shepherds, but at the same time the lowliness of God in this world was all too palpable. The old man Simeon spoke to you of the sword which would pierce your soul (cf. Lk 2:35), of the sign of contradiction that your Son would be in this world. Then, when Jesus began his public ministry, you had to step aside, so that a new family could grow, the family which it was his mission to establish and which would be made up of those who heard his word and kept it (cf. Lk 11:27f.). Notwithstanding the great joy that marked the beginning of Jesus' ministry, in the synagogue of Nazareth you must already have experienced the truth of the saying about the "sign of contradiction" (cf. Lk 4:28ff.). In this way you saw the growing power of hostility and rejection which built up around Jesus until the hour of the Cross, when you had to look upon the Savior of the world, the heir of David, the Son of God dying like a failure, exposed to mockery, between criminals. Then you received the word of Jesus: "Woman, behold, your son!" (Jn 19:26). From the Cross you received a new mission. From the Cross you became a Mother in a new way: the Mother of all those who believe in your Son Jesus and wish to follow him. The sword of sorrow pierced your heart. Did hope die?

Heart of Mary stained-glass window in Maria Kulm, Bohemia

Did the world remain definitively without light, and life without purpose? At that moment, deep down, you probably listened again to the word spoken by the Angel in answer to your fear at the time of the Annunciation: "Do not be afraid, Mary!" (Lk 1:30). How many times had the Lord, your Son, said the same thing to his disciples: do not be afraid! In your heart, you heard this word again during the night of Golgotha. Before the hour of his betrayal he had said to his disciples: "Be of good cheer, I have overcome the world" (Jn 16:33). "Let not your hearts be troubled, neither let them be afraid" (Jn 14:27). "Do not be afraid, Mary!" In that hour at Nazareth the Angel had also said to you: "Of his kingdom there will be no end" (Lk 1:33). Could it have ended before it began? No, at the foot of the Cross, on the strength of Jesus' own word, you became the Mother of believers. In this faith, which even in the darkness of Holy Saturday bore the certitude of hope, you made your way towards Easter morning. The joy of the Resurrection touched your heart and united you in a new way to the disciples, destined to become the family of Jesus through faith. In this way you were in the midst of the community of believers, who in the days following the Ascension prayed with one voice for the gift of the Holy Spirit (cf. Acts 1:14) and then received that gift on the day of Pentecost. The "Kingdom" of Jesus was not as might have been imagined. It began in that hour, and of this "Kingdom" there will be no end. Thus you remain in the midst of the disciples as their Mother, as the Mother of hope. Holy Mary, Mother of God, our Mother, teach us to believe, to hope, to love with you. Show us the way to his Kingdom! Star of the Sea, shine upon us and guide us on our way!

Encyclical *Spe salvi* (*Saved in Hope*), November 30, 2007

Pope Benedict XVI at the veneration of the Marian column in the Piazza di Spagna, Rome, December 8, 2007

MOTHER OF FAIR LOVE

On the path of Advent shines the star of Mary Immaculate, "a sign of certain hope and comfort" (*Lumen Gentium*, no. 68). To reach Jesus, the true light, the sun that dispels all the darkness of history, we need light near us, human people who reflect Christ's light and thus illuminate the path to take. And what person is more luminous than Mary? Who can be a better star of hope for us than she, the dawn that announced the day of salvation (cf. *Spe Salvi*, no. 49)? For this reason, the liturgy has us celebrate today, as Christmas approaches, the Solemn Feast of the Immaculate Conception of Mary: the mystery of God's grace that enfolded her from the first instant of her existence as the creature destined to be Mother of the Redeemer, preserving her from the stain of original sin. Looking at her, we recognize the loftiness and beauty of God's plan for everyone: to become holy and immaculate in love (cf. Eph 1:4), in the image of our Creator.

What a great gift to have Mary Immaculate as Mother! A Mother resplendent with beauty, the transparency of God's love. I am thinking of today's young people, who grow up in an environment saturated with messages that propose false models of happiness. These young men and women risk losing hope because they often seem orphans of true love, which fills life with true meaning and joy. This was a theme dear to my

Venerable Predecessor John Paul II, who so often proposed Mary to the youth of our time as the "Mother of Fair Love". Unfortunately, numerous experiences tell us that adolescents, young people and even children easily fall prey to corrupt love, deceived by unscrupulous adults who, lying to themselves and to them, lure them into the dead ends of consumerism; even the most sacred realities, like the human body, a temple of God's love and of life, thus become objects of consumption, and this is happening earlier, even in pre-adolescence. How sad it is when youth lose the wonder, the enchantment of the most beautiful sentiments, the value of respect for the body, the manifestation of the person and his unfathomable mystery!

Mary Immaculate, whom we contemplate in all her beauty and holiness, reminds us of all this. From the Cross, Jesus entrusted her to John and to all the disciples (cf. Jn 19:27), and from that moment she has been the Mother of all mankind, the Mother of hope. Let us address our prayer to her with faith, while we go in spirit on pilgrimage to Lourdes, where on this very day a special Jubilee Year begins on the occasion of the 150th anniversary of her apparitions in the Grotto of Massabielle. May Mary Immaculate, "Star of the Sea, shine upon us and guide us on our way!" (*Spe Salvi*, no. 50).

Angelus on the Solemnity of the Immaculate Conception, December 8, 2007

Virgin of La Almudena, Patroness of Madrid, leads a demonstration for the family, December 30, 2007

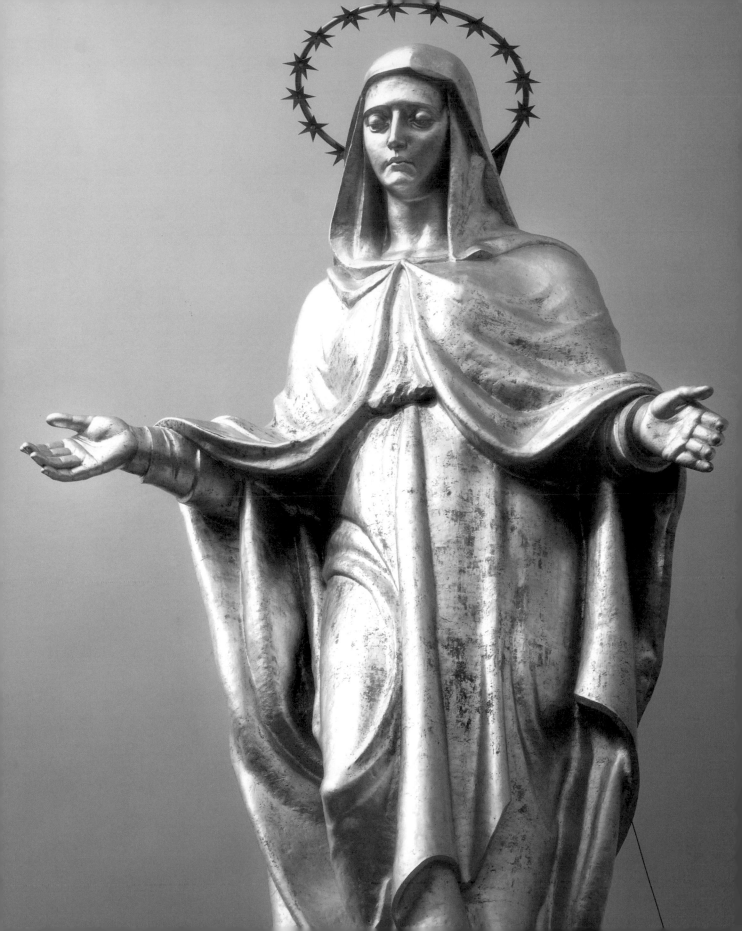

TEACH US, MARY

At an event which has now become a tradition, we are meeting here at the Spanish Steps to offer our floral tribute to Our Lady on the day when the whole Church celebrates the feast of her Immaculate Conception. Following in the footsteps of my Predecessors, I also join you, dear faithful of Rome, to pause at Mary's feet with filial affection and love. For 150 years she has watched over our City from the top of this pillar. Today's act is a gesture of faith and devotion which our Christian community repeats from year to year, as if to reaffirm its commitment of fidelity to her who in every circumstance of daily life assures us of her help and motherly protection.

This expression of piety is at the same time an opportunity to offer to all who live in Rome or who are spending a few days as pilgrims and tourists an opportunity, despite the diversity of cultures, to feel they are one family gathered around a Mother who has shared the daily efforts of every woman and mother of a family. She is, however, a completely singular Mother, for she was chosen in advance by God for a unique and mysterious mission: to bring forth to earthly life the Father's Eternal Word, who came into the world for the salvation of all people. And Mary, Immaculate in her conception—this is how we venerate her today—travelled her earthly pilgrimage sustained by undaunted faith, steadfast hope and humble and boundless love, following in the footsteps of her Son, Jesus. She was close to him with motherly solicitude from his birth to Calvary, where she witnessed his crucifixion, transfixed by suffering but with unwavering hope. She then experienced the joy of the Resurrection, at dawn on the third day, the new day, when the Crucified One left the tomb, overcoming for ever and definitively the power of sin and death.

Mary, in whose virginal womb God was made man, is our Mother! Indeed, from the Cross before bringing his sacrifice to completion, Jesus gave her to us as our Mother and entrusted us to her as her children. This is a mystery of mercy and love, a gift that enriches the Church with fruitful spiritual motherhood. Let us turn our gaze to her, especially today, dear brothers and sisters, and imploring her help, prepare ourselves to treasure all her maternal teaching. Does not our Heavenly Mother invite us to shun evil and to do good, following with docility the divine law engraved in every Christian's heart? Does not she, who preserved her hope even at the peak of her trial,

ask us not to lose heart when suffering and death come knocking at the door of our homes? Does she not ask us to look confidently to our future? Does not the Immaculate Virgin exhort us to be brothers and sisters to one another, all united by the commitment to build together a world that is more just, supportive and peaceful?

Yes, dear friends! On this solemn day, the Church once again holds up Mary to the world as a sign of sure hope and of the definitive victory of good over evil. The one whom we invoke as "full of grace" reminds us that we are all brothers and that God is our Creator and our Father. Without him, or even worse, against him, we men will never be able to find the way that leads to love, we will never be able to defeat the power of hatred and violence, we will never be able to build a lasting peace.

May the people of every nation and culture welcome this message of light and hope: may they accept it as a gift from the hands of Mary, Mother of all mankind. If life is a journey and this journey is often dark, difficult and exhausting, what star can illuminate it?

In my Encyclical *Spe Salvi*, published at the beginning of Advent, I wrote that the Church looks to Mary and calls on her as a "star of hope" (no. 49). During our common voyage on the sea of history, we stand in need of "lights of hope", that is, of people who shine with Christ's light and "so guide us along our way" (ibid.). And who could be a better "Star of Hope" for us than Mary? With her "yes", with the generous offering of freedom received from the Creator, she enabled the hope of the millennia to become reality, to enter this world and its history. Through her God took flesh, became one of us and pitched his tent among us.

Thus, inspired by filial trust, we say to her: "Teach us, Mary, to believe, to hope, to love with you; show us the way that leads to peace, the way to the Kingdom of Jesus. You, Star of Hope, who wait for us anxiously in the everlasting light of the eternal Homeland, shine upon us and guide us through daily events, now and at the hour of our death. Amen!"

Address at the veneration of the Marian column in the Piazza di Spagna, Rome, December 8, 2007

Marian icon at World Youth Day in Cologne, August 2005

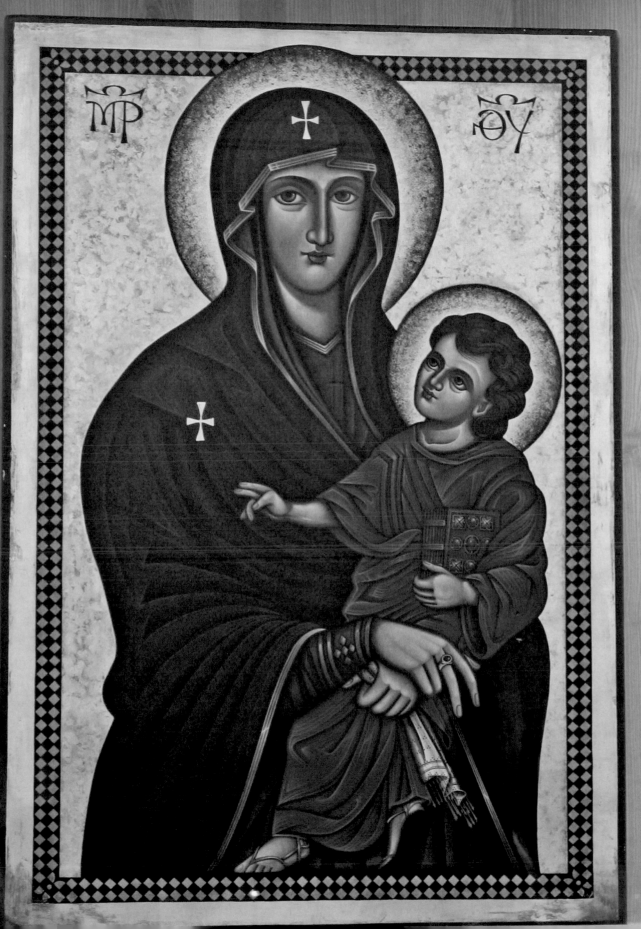

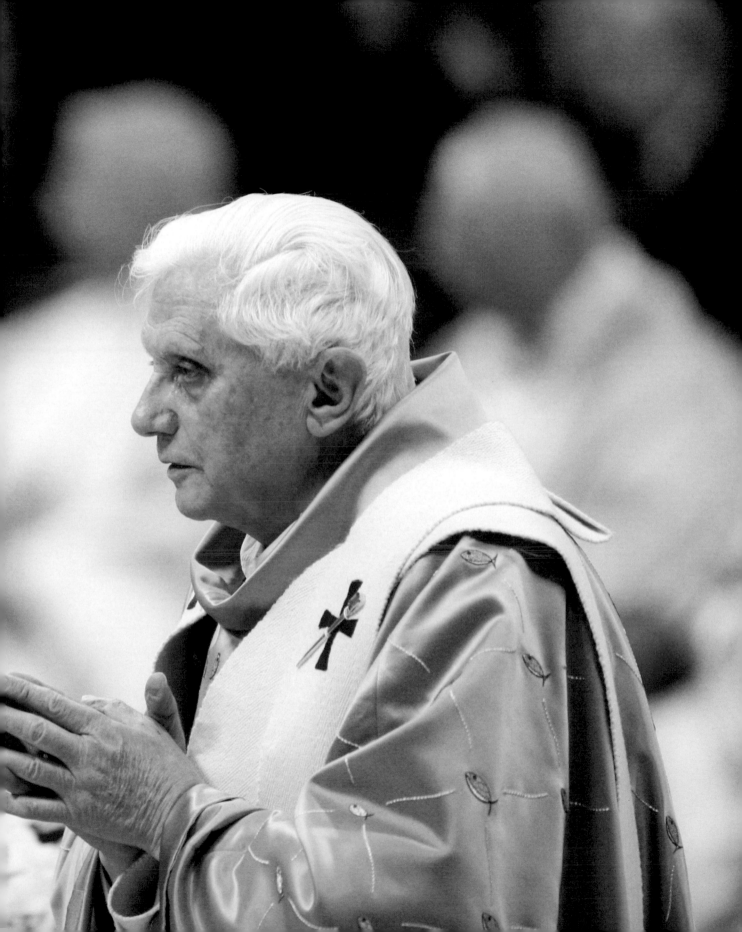

MOTHER OF GOD

Our thoughts now turn spontaneously to Our Lady, whom we invoke today as the Mother of God. It was Pope Paul VI who moved to 1 January the Feast of the Divine Motherhood of Mary, which was formerly celebrated on 11 October. Indeed, even before the liturgical reform that followed the Second Vatican Council, the memorial of the circumcision of Jesus on the eighth day after his birth—as a sign of submission to the law, his official insertion in the Chosen People—used to be celebrated on the first day of the year and the Feast of the Name of Jesus was celebrated the following Sunday. We perceive a few traces of these celebrations in the Gospel passage that has just been proclaimed, in which Saint Luke says that eight days after his birth the Child was circumcised and was given the name "Jesus", "the name given by the Angel before he was conceived in [his Mother's] . . . womb" (Lk 2:21). Today's feast, therefore, as well as being a particularly significant Marian feast, also preserves a strongly Christological content because, we might say, before the Mother, it concerns the Son, Jesus, true God and true Man.

The Apostle Paul refers to the mystery of the divine motherhood of Mary, the *Theotokos*, in his Letter to the Galatians. "When the time had fully come", he writes, "God sent forth his Son, born of woman, born under the law" (4:4). We find the mystery of the Incarnation of the Divine Word and the divine motherhood of Mary summed up in a few words: the Virgin's great privilege is precisely to be Mother of the Son who is God. The most logical and proper place for this Marian feast is therefore eight days after Christmas. Indeed, in the night of Bethlehem, when "she gave birth to her first-born son" (Lk 2:7), the prophecies concerning the Messiah were fulfilled. "The virgin shall be with child and bear a son", Isaiah had foretold (7:14); "Behold, you will conceive in your womb and bear a son", the Angel Gabriel said to Mary (Lk 1:31); and again, an Angel of the Lord, the Evangelist Matthew recounts, appeared to Joseph in a dream to reassure him and said: "Do not fear to take Mary for your wife, for that which is conceived in her is of the Holy Spirit; she will bear a son" (Mt 1:20–21).

Forgoing double-page spread:
Pope Benedict XVI at Christmas Mass, 2005

The title "Mother of God", together with the title "Blessed Virgin", is the oldest on which all the other titles with which Our Lady was venerated are based, and it continues to be invoked from generation to generation in the East and in the West. A multitude of hymns and a wealth of prayers of the Christian tradition refer to the mystery of her divine motherhood, such as, for example, a Marian antiphon of the Christmas season, *Alma Redemptoris mater*, with which we pray in these words: "*Tu quae genuisti, natura mirante, tuum sanctum Genitorem, Virgo prius ac posterius*—You, in the wonder of all creation, have brought forth your Creator, Mother ever virgin." Dear brothers and sisters, let us today contemplate Mary, ever-virgin Mother of the Only-begotten Son of the Father; let us learn from her to welcome the Child who was born for us in Bethlehem. If we recognize in the Child born of her the Eternal Son of God and accept him as our one Savior, we can be called and we really are children of God: sons in the Son. The Apostle writes: "God sent forth his Son, born of woman, born under the law, to redeem those who were under the law, so that we might receive adoption as sons" (Gal 4:4).

The Evangelist Luke repeats several times that Our Lady meditated silently on these extraordinary events in which God had involved her. We also heard this in the short Gospel passage that the liturgy presents to us today. "Mary kept all these things, pondering them in her heart" (Lk 2:19). The Greek verb used, *sumbállousa*, literally means "piecing together" and makes us think of a great mystery to be discovered little by little. Although the Child lying in a manger looks like all children in the world, at the same time he is totally different: he is the Son of God, he is God, true God and true man. This mystery—the Incarnation of the Word and the divine motherhood of Mary— is great and certainly far from easy to understand with the human mind alone.

Yet, by learning from Mary, we can understand with our hearts what our eyes and minds do not manage to perceive or contain on their own. Indeed, this is such a great gift that only through faith are we granted to accept it, while not entirely understanding it. And it is precisely on this journey of faith that Mary comes to meet us as our support and guide. She is Mother because she brought forth Jesus in the flesh; she is Mother because she adhered totally to the Father's will. Saint Augustine wrote: "The divine motherhood would have been of no value to her had Christ not borne her in his heart, with a destiny more fortunate than the moment when she conceived him in the flesh" (*De Sancta Virginitate* 3, 3). And in her heart Mary continued to treasure, to "piece together" the subsequent events of which she was to be a witness and protagonist, even to the death on the Cross and the Resurrection of her Son, Jesus.

Dear brothers and sisters, it is only by pondering in the heart, in other words, by piecing together and finding unity in all we experience, that, following Mary, we can penetrate the mystery of a God who was made man out of love and who calls us to follow him on the path of love; a love to be expressed daily by generous service to the brethren. May the new year which we are confidently beginning today be a time in which to advance in that knowledge of the heart which is the wisdom of saints. Let us pray, as we heard in the First Reading, that the Lord may "make his face to shine" upon us, "and be gracious" to us (cf. Nm 6:24–27) and bless us. We may be certain of it: if we never tire of seeking his Face, if we never give in to the temptation of discouragement and doubt, if also among the many difficulties we encounter we always remain anchored to him, we will experience the power of his love and his mercy. May the fragile Child who today the Virgin shows to the world make us peacemakers, witnesses of him, the Prince of Peace. Amen!

Homily at the Solemnity of Mary, Mother of God, January 1, 2008

Pope Benedict XVI with Marian miter at the naming of new cardinals in Saint Peter's Basilica, November 24, 2007

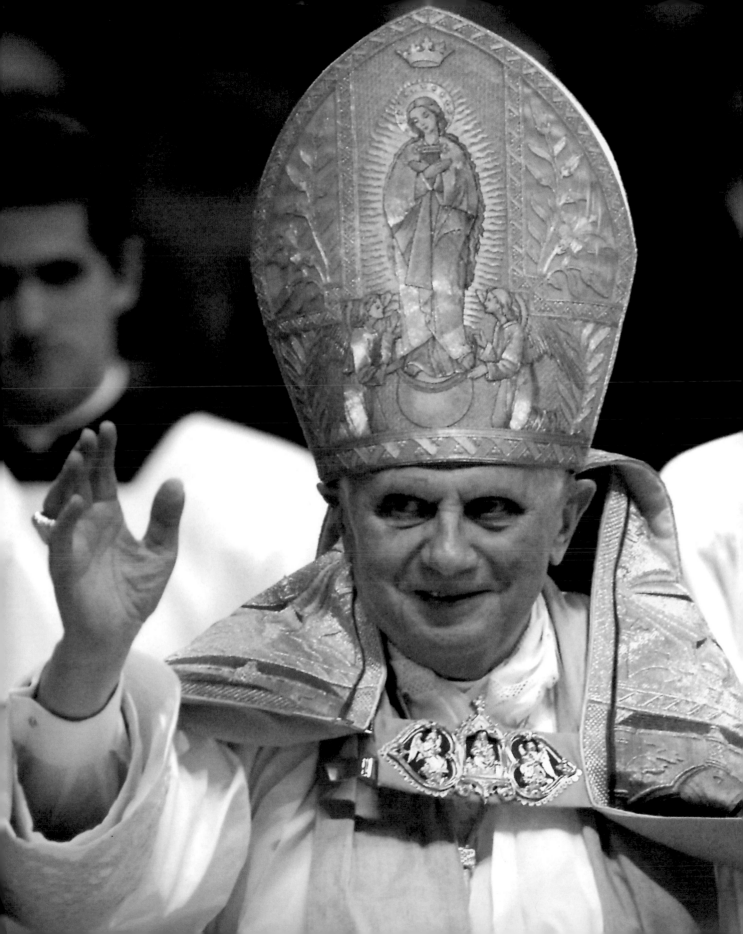

ART CREDITS

Grzegorz Gałazka: 18, 22, 32, 40/41, 57, 58/59, 69, 74, 82, 85, 86/87, 88, 92, 106/107, 110/111, 134/135, 149, 150/151

KNA: 43, 62, 65, 66, 73, 78, 80, 83, 96, 99, 103, 125, 130

Marie-Lan Nguyen: 50

picture-alliance/dpa: 145

Hildegard Pollety: 8

Sankt Ulrich Verlag: 47, 122

Servizio Fotograficó de L'Osservatore Romano: 94/95

Stefano Spaziani: 7, 14/15, 20/21, 26/27, 34, 36/37, 44/45, 61, 67, 100, 105, 109, 112, 114/115, 117, 126/127, 129, 132, 140, 142, 146, 155

Michael Westermann: 11, 17, 24, 28, 31, 38, 49, 54/55, 70, 76/77, 91, 118, 120, 136, 139